Jytte Fogh Lokvig, Ph.D.

The Alzheimer's

Creativity

Project•2

Second Edition

Endless Circle Press

Copyright: © Jytte Lokvig 2020

ISBN: 978-1-64921-660-1

LIBRARY OF CONGRESS CONTROL NUMBER:

Drawings by the author
(Any resemblance to actual persons is purely coincidental)

Endless Circle Press
228 Ojo de la Vaca Rd.
Santa Fe, NM 87508

505-501-2412
e-mail: lokvig@gmail.com
Other books by Jytte Fogh Lokvig, Ph.D.
>	Alzheimer's A to Z, Secrets to Successful Caregiving
>	Alzheimer's A to Z, A Quick Reference Guide
>	Alzheimer's Creativity Project, First Edition
>	Alzheimer's and Memory Cafés
>	Alzheimer's and Dementia Handbook
>	Moving and More
>	Dementia Arts Fest

Reviews

This wonderful book is a rare combination of practical, funny, and most of all incredibly optimistic ways to engage and support elders. Her many years as an advocate for elders, dementia specialist, artist, and daughter show in each page. The Alzheimer's Creativity Project is a solid book for connecting elders who are living with Alzheimer's to life through creativity, humor and common sense. In the more than 20 years that I have known her, Jytte has shown a tireless devotion to pushing the often narrow, bleak definitions our society has of elders in this world toward joy, laughter, creativity and engagement. Her presence in the community of Santa Fe and in the elder community period is a great benefit to elders, families and professionals. Her writing reflects this commitment and advocacy, which are needed, especially in this time of isolation and fear.

Ruth Dennis, MA
Co-Author "Mindful Dementia Care"

When I was a caregiver for my mom who lived almost ten years in an expensive, fairly well regarded, private assisted care facility for people with dementia, one of the things that concerned me most was the lack of fun or interesting things for the residents to do. I was assured activities were a part of every day prior to placing my mom there, but when I visited, unless the assistant director/activity person was available, which she often wasn't due to other responsibilities, I'd find the residents sitting in their rooms, blankly staring at TV in the living room, or walking around the facility, awaiting a visitor or the next meal, with nothing interesting to do, and no one to interact with. I've often commented that just because someone has lost their memory doesn't mean they've lost their mind, or don't appreciate interaction with others that involves doing something meaningful and fun, uses various parts of the brain and requires some focus and creativity.

Patricia Connoway,
Author: Listening with my Eyes

Dr Jytte Lokvig does it again! "The Alzheimer's Creativity Project," truly is the caregivers' ultimate guide to a good day! Through a wide variety of examples on how to engage, there is something for everyone to enjoy. The simple fashion in which all projects are explained, makes this a mandatory resource book; for communities, professionals and families. - Thank you Jytte for giving hope and removing fear when engaging with those with dementia. I can only say, "I wish I had this book during my thirty-year journey with my own mother."

 Lori La Bey Alzheimer's Speaks Radio

From introducing America to the concept of Alzheimer's Cafés, to helping countless people express their creativity, this book confirms Jytte is a leader in the movement to treat people living with Alzheimer's disease with honor and respect.

 Gary Glazner
 Founder: Alzheimer's Poetry Project.

Contents

Acknowledgments

My deep appreciation to all of you who've supported my work for all these years. I've had steadfast support from the Santa Fe community at large for the Alzheimer's Café since I started it in 2008, first and foremost the generosity of the Santa Fe Children's Museum, our "home" since 2009; Sandra Oppenheimer and Suki Groseclose and their families; Roxanne Brie, and Mark Kaltenbach. Also special appreciation to Jan Olsen, Sue Foley, and Susan Robinson for your solid support of the Alzheimer's Café; Trish Foschi and Stuart Hall, and thank you to the hundreds of our guests over the years.

And none of this would have been possible without the families who supported me as we explored all the possibilities of improving life with Alzheimer's and related dementia. I so appreciate your generosity, trust and sense of adventure.

I feel privileged to know so many selfless and empathetic souls, some who're living with memory-impairment, others who're doing their best to improve their lives. Many of my colleagues are members of the Pioneer Network and the Dementia Action Alliance, Karen Stobbe and Mondy Carter, Bill Thomas and Al Power, Jackie Pinkowitz, Karen Love and Kim McCrae; Gary Glazner and Teepa Snow; Cathy Michaelson Lieblich and Sonya Barsness. Kate Swaffer, Bere Miesen, and Gemma Jones; I have gained so much from knowing you and your work.
– and there are so many more of you. Thank you, thank you!

And of course, YOU, my beautiful family! I'm so proud of your kindness, compassion, and dedication to others. You continue to inspire me. I love you beyond measure.

Foreword

Living with Alzheimer's

By Susan Balkman

I first discovered I was having problems when I could not remember where I was going, when I was totally confused, afraid, or having this blankness come over me. My verbal skills were more challenging and I started not to be able to handle numbers anymore, i.e., money, paying bills, etc... My friends gently let me know that I might want to see someone. They had known me for 8 years and had noticed a marked decline in my language and thought processes along with confusion and personality changes.

I was officially diagnosed with dementia, probably of the Alzheimer's type. I was still young and otherwise healthy. Knowing I probably had many years ahead of me, I asked the doctors for advice going forward. All they told me was to get my papers in order. I was confused and felt lonely and lost.

Hoping to understand what to expect and how to manage symptoms, I met with Dr. Jytte Lokvig. Jytte is an expert in dementia/Alzheimer's.

When we first met, I felt she was the first person to understand what I was saying; Jytte normalized what is not normal. She gave me hope! - And direction. One of her first questions after my crying through the beginning, and trying to look professional, was what do I like to do that is creative!

Creativity has been an essential key to my wellbeing in dementia. I am a therapist by trade and a potter by love. When I first started back at Santa Fe Clay (after my diagnosis) I was not able to talk very well. People would ask me how to do something. People gently would give me the word. This is important, most people who have dementia, including Alzheimer's, are challenged at some point with verbal expression. It is not that I do not have the idea or verbal concept, I am just unable to speak. When you talk with someone with dementia, they may understand and sometimes they don't. Do not assume that your family member or friend does not

understand even when they cannot express themselves. It takes time, sometimes it just does not compute, — but most of the time it does. This does not mean 5 minutes later the person will remember. I have learned to say, "Give me a minute." Sometimes I can find the words, sometimes not; sometimes I totally forget what I am thinking about. Maybe it did not need to be said, or maybe as a society, we are moving so fast that when faced with something new we cannot wait or adjust.

Purpose! Without which, I would not function. Pottery has been my salvation

Introduction

CREATIVITY to me means letting go of our old notions of doing something, being open to new experiences and allowing ourselves to think out of the box and go with the flow and ebb of our situation and the people with whom we work when it comes to everything we're called to do, from helping someone to shower to starting a singalong to cheer everyone up in the late afternoon. In other words, I think of CREATIVITY in the broadest sense of how we approach everything we do throughout the day.

From the Reference Dictionary: Creativity:

1.

The state or quality of being <u>creative</u>.

2.

The ability to transcend traditional ideas, rules, patterns,

relationships, or the like, and to create meaningful new ideas,

forms, methods, interpretations, etc.: originality, progressiveness, or imagination: *the need for creativity in modern*

industry; creativity in the performing arts.

One of the gifts of Alzheimer's is the loss of old parameters, hangups, notions, and habits, freeing people up to simply experience everything in the moment. When we lend ourselves to our residents they may gift us with experiences that we would probably never think of otherwise. One of my clients took me on a year long quest for the perfect chocolate ice cream. Another loved to navigate our drives around town with the challenge of getting lost, which we never achieved, by the way.

Our long-term care facilities have come a long way in last several decades. Private-pay establishments usually feature beautiful grounds, imposing lobbies, and elegant dining rooms. Picture perfect — for resorts!

As perfect as these residences may appear, you may hear this from people living there: "Oh, this place is nice enough, the food is good, and everyone is kind, but there's nothing to do here." — "They (staff) decide everything for me: when and

what I eat, when I go to bed, and what I wear." In this country, our care facilities still tend to be updated and dressed-up versions of the old convalescent hospitals. In other words they follow the medical model where the focus is on **what's wrong** with a person rather than **what's right**. We're very good at caring for the physical needs of our residents, but we still have a long way to go to pay adequate attention to their emotional and intellectual wellbeing. We may even refer to our assisted living residents as "patients."

> *According to Webster Dictionary a *patient* is an individual awaiting or under medical care and treatment. ORIGIN Latin *patient- 'suffering,'* from the verb *pati*.

I can't fault the assisted living industry alone since almost all of the healing professions are focused on "curing" Alzheimer's and dementia, something that may remain incurable, often to the exclusion of concern for the emotional needs of the individuals currently living with these conditions.

Until relatively recently, care facilities were not even mandated to provide activities and sadly the prevalent attitude still is that an activity program is an added feature of the facility, a bonus. As far as I'm concerned this is backwards thinking. In our own lives we don't differentiate between "activities" and daily life, do we? It's high time we bring this mind-set into caregiving in our institutions.

Our daily routines, also known as ADLs (activities of daily living), don't need to feel like chores. Instead we can make this daily activity a very special private one-on-one time between resident and caregiver. This can be the time to share stories and memories. Helping someone brush her teeth and get dressed are very intimate acts that can perfect opportunity for us to reinforce our bonds. My personal routine was to start the day with "Good Morning To You," (to the tune of Happy Birthday) I wanted to make sure my client knew I was really glad to see her. — And, considering that most of my clients have been in their late eighties into their nineties, every new day was indeed to be celebrated. When we think in those terms, it changes our thinking and attitudes. By making a few changes in our

communication and approaches, we can change the lives of our residents and turn our own daily tasks into rewarding, purposeful, and interesting experiences.

There is a growing awareness of the need to rethink the culture within our facilities, including how we expect staff to balance their tasks with interactions with residents.

It's a matter of rethinking staff responsibilities and getting away from certain tasks being the sole the responsibility of this staff or that, depending on job descriptions and assignments that particular day. Instead, if we think of our facility as one big family, the lines become blurred between residents and staff. Personal care aides, nurses, managers, activity staff, and housekeepers can all pitch in and participate in daily life, from chores to celebrations and activities. For example if I'm a personal aide, who loves to read and write poetry, I might share some of my personal collections and lead a poetry/story writing group — or, if I have a half way decent voice (or simply enough guts to sing out loud, in tune or not) I can lead an impromptu sing-along with a group of residents, freeing up the activity aide to work with special interest group. Or - if I've always wanted to learn to build coiled clay pots, I might sit in on a pottery session and learn right along with the residents. This doesn't take away from my ability to fulfill my assignments; on the contrary, working side-by-side with my residents strengthens our individual relationships, making my routine tasks smoother and my job more enjoyable. The way we feel about our day influences all those around us. And, when we share positive experiences like these with our residents our relationships change and the necessary

Fortunately there is a vigorous and expanding movement in this direction. The primary examples are the *Green House Projects* and facilities that subscribe to *culture change* and the *Eden Alternative* philosophies. Good resources are the *Pioneer Network* and the *CMS Hand-in-Hand* training series.

> Creativity involves breaking out of established patterns in order to look at things in a different way.
>
> Edward de Bono

Understanding Dementia

Alzheimer's and Related Dementias
A *very, very* short primer
"Dementia" is not a disease as such, but rather a term used
for **symptoms** shared by hundreds of different brain disorders.

Alzheimer's Disease - Most common dementia; accounts for 60 - 80 percent of cases.

Vascular Dementia - Multi-infarct, or post-stroke dementia

Mixed Dementia - Alzheimer's combined with another type of dementia

Lewy Bodies Dementia - Similar to Alzheimer's. Prone to hallucinations.

Parkinson's Disease - Many people with Parkinson's disease also develop dementia.

Frontotemporal Dementia - Damage to the front and side regions of the brain.

Pick's disease - A type of frontotemporal dementia.

Creutzfeldt-Jakob Disease – In some cases diagnosed as Mad Cow disease

*** Normal Pressure Hydrocephalus (NPH) -** Caused by the buildup of fluid in the brain. May be reversible.

> **Other reversible conditions that mimic dementia:** Drug reactions, malnutrition, dehydration, infections, anesthesia. At the first sign of acute confusion and memory loss, see your doctor; a sudden onset of confusion or delirium may indicate a reversible condition.

Remember: *There's much more to each of us than our memory and even if our personalities may change, our personhood stays intact until our last breath.*

Keep in mind that no two of us are identical and this is especially true of people living with dementia and Alzheimer's.

At some point we have all forgotten something: where we put our keys, the names of people we met last week, the container of Chinese takeout from last month that's sitting in the back of the refrigerator, — or to pay a bill. Some of the things on this list may mean little or nothing in isolation. However, when a person shows several signs consistently, it's time to become proactive. So when you review the list, look for changes in behavior along with a decline in cognitive ability and often personality changes.

Warning Signs Of Dementia-

* Short-term memory loss
* Forgetting names of familiar people
* Depression
* Repetitions
* Hoarding newspapers, brochures and magazines
* Forgets to pay bills
* Difficulty performing familiar tasks (cooking, using a telephone)
* Increasingly suspicious of others
* Accusatory
* Has increasing problems remembering important appointments
* Getting lost on familiar routes
* Spoiled food in the refrigerator
* Forgets personal care routines (brushing teeth, dressing)
* Forgets to turn off stove, water, or iron (frequently)
* Sleeping in day clothes
* Losing awareness of time and space
* Sudden secrecy
* Storing items in inappropriate places (i.e. iron in the freezer)
* Tells fantastic tales
* Loss of initiative, becoming passive
* Victim of telemarketers, opportunistic home repairmen
* Entering sweepstakes obsessively
* Acting to many mail or phone solicitations
* Sending money to every phone or mail solicitation
* Changes in personality
* Home unkempt
* Bouts of extreme anger or rage
* Profuse explanations
* Increasing difficulty keeping up with conversations
* Excuses for everything
* Vehemently dismisses concerns

* Often refuses support
* Avoidance
* Unusual vagueness
* Irrational shopping
* Obsessive behavior
* Unkempt
* Forgets to eat or doubles up on meals
* Loses weight
* Dirty clothes/not changing
* Wears the same clothes days on end
* Not bathing
* Withdrawal from friends and family
* Accumulated mail
* No longer doing favorite things, hobbies
* Personal grooming neglected
* Consistently forgets or is vague about recent events

WHEN TO SEE A DOCTOR?

If you have checked yes on many of the items on the list, it's a good indication that there's more than normal age-related memory loss. "Dementia" is an umbrella term for numerous different brain diseases, of which Alzheimer's is the most common. There are several hundred dementias that share many of these symptoms. Before you jump to the conclusion that this is a specific dementia, it's important to undergo a complete physical as soon as possible, primarily to eliminate reversible dementias, known as "delirium," which may be caused by treatable conditions, such as thyroid imbalance, dehydration, drug interactions or reactions, low-grade infections, NPH (normal pressure hydrocephalus), and more. At this time, a diagnosis of *dementia of the Alzheimer's type* is reached primarily by process of elimination. Alzheimer's disease can be diagnosed with absolute certainty only at autopsy; however, specialists are able to identify it with a success rate of 90%, using especially structured memory tests and MRIs. Alzheimer's is in fact one of the gentler versions of dementia.

Current medications: To this date, we have no dementia cures in sight. Donepezil (Aricept), galantamine (Razadyne) and rivastigmine (Exelon) are cholinesterase inhibitors that boost levels of cell-to-cell communication in the brain. Memantine (Namenda) works on another issue in brain communication and is sometimes used in combination with a cholinesterase inhibitor. These drugs may slow the progression of the disease temporarily for a few people if given to them in the earlier stages. The functional words here are "*may* slow" and "a *few* people"

These medications are expensive and some people find the side effects intolerable. And they are not a cure-all and at best only about half of the patients find any benefits from them and apparently the benefits are minimal.

I totally trust that one of these days, we'll find a way to halt these brain-disorders, but even when we do, there will still be millions of people continuing to live with dementia, which means we'll still need to use all the tools outlined in this book.

Good food: Anything that's good for our heart health is good for our brain health, especially foods high in anti-oxidants, such as fruits and vegetables, the darker the better, i.e., blueberries and dark greens. We recommend a Mediterranean diet. More good news: I'm sure you've heard about the benefits of dark chocolate as well (in moderation)! — And as much as possible, stay away from processed and white foods, including sugar.

Feeling good: Above all, feelings are as important to a person with dementia as they are to any of us. We all want to feel safe, of value, and hopefully loved. This can be really hard to keep in mind when you're caring for someone who needs help with practically everything. It's exhausting and often demoralizing.

Go easy:

let go and let flow

Words Matter

The words we use affect our feelings toward our situations and the people we care for. If we talk and think of caregiving as a ***burden,*** it most certainly will be so. When we call a person an *empty shell*, we'll think of her and treat her as such and she'll likely withdraw into herself and "prove" us correct.

We don't normally identify people by their disorders or diseases: i.e. If we have chronic conditions like diabetes or scoliosis, we wouldn't want to be referred to as a diabetes person or scoliosis person, would we? How would feel if these words were used about you?

Alzheimer's person, Demented person should be <u>"A person living with Alzheimer's or dementia"</u>

Crippling, Demented, Victim, Sufferer, Invisible, Fading, Not all there, Empty shell, Losing it – These terms assume that we should use our own standards to judge others. Well, in that case, whose standards? — Yours or mine?

Behavior problem, challenging behaviors, difficult behaviors. Often the "problem" is with the caregiver and a lack of understanding communication. A person who has lost his ability to communicate with words will resort to other ways. If he's frustrated that you don't get the urgency of his problem, he may flail, gesture, make loud noises or even strike out. We call this "behavioral expression" - Similar to what we'd probably do if we were stuck in a foreign country and needed help but didn't know the language?

Fighting Alzheimer's, War on Alzheimer's, Win over or beat Alzheimer's, Battling Alzheimer's. Combative terms keep us in a negative and often hopeless state. Until we come up with a cure, Alzheimer's and other dementias are chronic conditions and for everyone's sake, let's make the best of our situations.
Patient is relevant only in a medical sense. Doctors, nurses, dentists, therapists etc have patients; the rest of us have residents, clients, friends , etc.

Vocalizer, Aggressor, Wanderer, Sundowner, Feeder. When we describe people by their behavior, we've stripped them of their humanness. We don't describe each other by our actions, so why do so with people with dementia? Could you imagine how you'd feel if others referred to you by your habits rather than your name, i.e. ***Texter***, ***Head-scratcher, Backseat-driver,*** etc

Memory Care, Memory Café, Oxymorons that are offensive to people with dementia. We understand that it would be inappropriate to announce a "walking" club for paraplegics.

And lastly ***The long goodbye.*** Pleeeeeeease! This may be the most cruel of all. Does this mean that a person starts dying as soon as he is diagnosed? In that case, we could legitimately start using that term with any newborn infant, because the truth is we're all dying a little every day of our lives. So, to borrow from Richard Taylor who lived well for over ten years with a diagnosis of dementia, probably of the Alzheimer's type: "I'm still ME, so let's say HELLO"

Heard far too frequently:
"Gee - you don't look like you have dementia"

Welcome to the World of Alzheimer's

And other dementias

In the early nineteen-nineties I was focused on building my house and the last thing on my mind was anything related to elders. That is, until an acquaintance called me on a snowy day in January of 1994. She would be away on business for the next several months and needed someone to visit with her mom, Norma, who lived in a retirement home downtown. Would I mind stopping in for a few minutes when I was in town anyway, picking up mail and supplies? I hadn't met her mom, but I decided that it couldn't be that big a deal, so why not?

Norma was a perfect delight during our first visit, so I felt confident when I returned a few days later with a package of cookies and a couple of tea bags. I made us some tea, prepared a plate of cookies and we settled down in the living room. Everything was going along just fine and I thought this would be a pleasant break from my regular routines. Suddenly her demeanor took a dramatic shift; she gave me a strange look, her face scrunched up into a deep scowl and she screamed at the top of her lungs, *"Who the h*#& are you? What are you doing here? Get the f*#@k out of my house!"* I was too stunned to say anything — instead, I sheepishly picked up my bag and made a quick exit. On the way out I stopped by the nurses' station to learn what was happening. The nurse said, "Alzheimer's," - I knew little to nothing about Alzheimer's. In 1994 it was not yet a mainstream topic, but was still one of the many obscure diseases that we don't pay attention to unless we're personally affected by it.

The library had only one major book on Alzheimer's: *The 36 Hour Day*. That particular edition of the book (1987) painted the bleakest picture possible, starting with this message: you have embarked on *the* most challenging job: *caring for a person with dementia — and it's only going to get worse. There's no cure, no prevention and no hope.* After ten pages I couldn't continue, thinking, "Oh, my God! What have I gotten myself into?" - I had committed to three months of visits and I had to

find a way to make it work. I decided I had no choice but to follow my instincts. It certainly couldn't be much harder than my work for many years as a teacher. - That casual commitment to Norma turned into a career. Here I am, a couple of decades later, my energy is focused on changing how we support our memory-compromised elders.

At first, like many other novices, I made numerous mistakes interacting with my new friends with Alzheimer's, mostly in my communication, but still within that first year I knew I had found my "calling." In the very beginning I relied on the advice from people who had experience working for years with this population, but increasingly it became clear that much of what I was told simply didn't work or could be approached differently for better results. For example, up until the mid-nineties, professional Alzheimer's care circles still promoted *reality orientation*. The belief at the time was that you could make a person retrieve memories by having him repeat them over and over again.

My best "teachers" have turned out to be my own clients, residents and friends who're living with Alzheimer's or dementia. I learned to let go of my expectations and preconceived notions and to *lend* myself to each individual and each particular situation.

Through trial and error my awareness grew; I kept notes on my own failings, successes and little triumphs and after a couple of years I realized that these notes on what I had learned might help other people, so I assembled them into a reference guide for caregivers. It was published as *Alzheimer's A to Z, Secrets to Successful Caregiving* - later a revised and updated version was released as *Alzheimer's A to Z, a Quick Reference Guide.* (see Addendum)

The gift of Alzheimer's can be to teach us to simply BE and appreciate each other as unique individuals with something to contribute, big or small. Whether we're residents, family members, personal aides, nursing or activity staff, we can let go of the roles and celebrate that we are here, — now — in the moment. Take a deep breath, let go and lend yourself to the person you're with.

On Purpose
My Purpose in Life with Alzheimer's Disease
by Brian LeBlanc

Life can offer you many challenges and it can also give you many choices. When it comes to my Alzheimer's Disease, it has offered me both.

It challenged me to make a choice between living the best life I can or do nothing and let this horrendous disease consume me. Well, if you know me, you know that I was not going to allow myself to be consumed.

If you live a life without purpose or direction, you are still living but you are just existing. I could've done nothing after my diagnosis but what would that have done. NOTHING!

Instead, I chose to make a difference, to educate, to share my Alzheimer's Journey with the world so that everyone could see that just because you have a Diagnosis of some kind doesn't mean you stop living.

The responses and questions I receive every day tells me that I am making a difference in the world. For that I am grateful and keeps me *Purposefully Strong!*

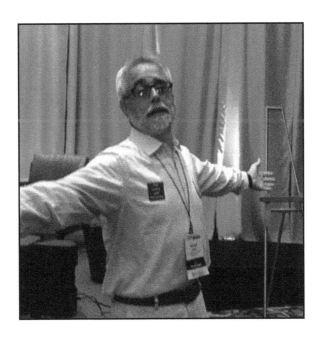

A Few Minutes-A Big Difference

I was early for a training session with the staff at a large nursing home, so I decided to wait in the lunchroom. Several residents were still eating, while half a dozen who had finished were lined up in their wheelchairs waiting to be escorted back to their rooms. One woman in a wheelchair was off by herself, crying loudly, "Help, help, help me." An aide rushed past her, close enough to brush up against her arm. Several other staff were eating their lunches at a corner table, a few feet away.

I watched this scenario for a while. The staff was oblivious to her cries and it was soon apparent that nobody would do anything, I went to the unhappy resident's side, asked her name and how I could help. She told me she was afraid to be left behind, so I wheeled her to the back of the line of the wheelchair line and reassured her that someone would help her in a few minutes. She smiled, relaxed into her chair and closed her eyes for a quick nap.

This woman's outcries were likely such a frequent and annoying occurrence that the staff had conditioned themselves to ignore her outbursts.

However, when one person is obviously upset like this, it affects everyone else around her. There's often a snowball effect in these situations. One person's loud outcries can cause agitation in others, which in turn can affect their interactions with staff. It would have been so easy for the staff person to give her a few seconds of attention, thus putting her at ease, which would help everyone have a much better afternoon, the residents and staff alike.

The physical and chemical changes in the brains of people with Alzheimer's affect comprehension and memory as well as mood, energy and spirit. He's more

susceptible to outside stimuli and has less control over his emotions. Feelings, good and bad, linger much longer in people with dementia and Alzheimer's. When we experience sadness or grief, most of us are able to reason ourselves out of our blues and our strong feelings fade pretty quickly. People living with dementia may no longer possess this ability. For them, unchecked, these feelings tend to last a lot longer, often unchanged in intensity. Sadness and anger tend to linger longer than happy and joyful feelings. With that in mind, you can see the importance of maintaining a positive atmosphere.

When loss of self-control is combined with *aphasia** experienced by many as their dementia progresses, and may lead to sudden outbursts, agitation, and aggression. This is known as *behavioral expression*. When we can't express ourselves in words, it's natural to find another way, such as lashing out, throwing things, yelling obscenities.

**aphasia*: Difficulty finding words or loss of speech.

As hard as it may be in the moment when things are going haywire, try to refrain from reacting. Instead, take a couple of deep breaths, excuse yourself and take a minute or two in the next room or outside. When you've pulled yourself back together, re-enter and pretend nothing happened. Talk about something innocuous and unrelated to whatever caused his outburst. If he still seems really agitated, ask him how you can help him, keeping your tone calm and positive.

This important piece of advice sounds a lot easier than it is for most of us:

> **DON'T REACT TO ATTACKS,** don't justify or explain, or try to reason and above all, *DON'T DISAGREE OR ARGUE!* (you'll never win)

With practice, you will strengthen your self-control — and your deep breathing will have improved. Finally, hard as it is to remember this: These episodes are caused by the dementia. Try not to blame him or yourself.

It took me some time and quite a few blunders to realize that to make this work, I'd have to learn to speak "dementia" — starting with these basics:

Communication

"The key to everything is communication"

Listen!

Avoid Baby Talk – use normal adult speech

USE COMPLIMENTS AND HUMOR

(a lot, — but never at your companion's expense)

Never argue, scold or criticize

Avoid: "Do you remember?" ...

Use with care: "Do you want?"

Avoid using **"NO!"**

Use Diversions and Loving Lies

Respect altered realities

Be aware of behavioral expressions

And don't forget about what your body language

Listen

Caregiving involves performing tedious routines on a daily basis. Under those circumstances it's hard to remember that while these may be routines to us, to a person with demented each time may be a new and scary experience. For example if your resident is in a wheelchair you move it countless times during the day and it may be hard to remember that each move may be startling to her. After all, it's normal to think she ought to be used to it by now. However, can you imagine how it feels to have "the rug" yanked out from under you? Try it sometime. Sit in a wheelchair and have someone move you without warning — it feels very insecure

and I suspect a person never really gets used to it. So, please make a habit out of talking through your actions to let the person know what you're going to do. It can be a brief remark: "I need to move you, okay?"

Gently tell her a moment before when you need to do something that may startle her, i.e., straightening out blankets, pillows or bedding; putting on or removing a piece of clothing or shoes; buttoning something; performing a grooming action, such as combing her hair or wiping hands. As much as possible let her take the lead.

It sounds so simple that we should listen to our residents, but truth be told, many of us are not very good at hearing each other. When you're with a person with Alzheimer's or a related dementia, try to take the time to really listen. Your resident may have aphasia making it difficult for her to form words and sentences; however this does not necessarily indicate diminished comprehension or reasoning. So when she mutters something, take a deep breath and concentrate on what she's trying to say and simultaneously to what her body language is telling you.

Eye contact. Always approach from the front. If your resident is snoozing or appears to be off in her own world, you may need to get her attention. Lean down to eye level and gently tap her knee. Before you say or do anything else, make eye contact with her to gain her full attention. This is especially important when you need her cooperation with a specific action, such as changing her clothes, giving her medication or brushing her teeth.

Body Language. Catherine was determined never to burden anyone with her problems, so she would try her best to avoid conversations, questions, or anything

else relating to herself. Compliments made her embarrassingly uncomfortable and she went out of the way to avoid complaining when something was wrong — or showing discomfort or pain. Unfortunately she was prone to frequent urinary tract infections (UTI) that can lead to other serious infections, so it was important for us to know when we needed to intervene before the infection spread. We paid close attention to Catherine's body language. Her appetite, demeanor and movements would change. When she refused a brownie, was exceptionally quiet, or started squirming in her seat, we knew it was time to call the doctor.

Baby Talk

It's normal for human beings to change our voices into a higher register and softer tones to express sympathy and compassion. It may be hard to distinguish between compassion and condescension. What may be meant as an expression of concern or simple kindness, can feel demeaning? Unfortunately I've often witnessed this kind of unconscious condescension from both staff and visitors.

Just imagine yourself on the receiving end of cutesy tones and baby talk.

Example: Three of us were sitting side-by-side, relaxing in easy chairs after lunch: One of the residents in the memory care wing, flanked by me on one side and her husband on the other. The facility's marketing person was giving a "tour" to a few people. As the group passed us, one of the visitors bent down in front of the husband and very sweetly said, "Hi, how *are* you?" The visitor's tone of voice clearly suggested that she thought the husband was an impaired resident as well: A little too sweet and condescending.

She meant well, trying to *connect* with a person she assumed to be disabled because of the circumstances and his appearance. He was perfectly lucid, but had a mane of white hair and a handsome man with wrinkles appropriate for someone in his eighties. Most of us have a tendency to change our tone we someone we perceive as being weak and vulnerable. So, the point is not so much that the visitor was mistaken but rather that she didn't realize that nobody wants to be considered an object of pity, as the visitor's tone had suggested, even when they are in the very advanced stages of dementia.

Example: I was wheeling my friend down the hall when we were approached by one of the other residents. She bent down to make eye-contact and with sweetness oozing, cooed, "Oh, you look so cute in your blue blouse to match your pretty blue eyes." Normally, I would not have reacted, but my friend was cringing so intensely that I could feel her tension through the handles on the chair. - I locked eyes with the thoughtless resident and firmly said, "I'm sorry but my friend doesn't appreciate baby talk; she's an adult and prefer to be addressed as such."

Compliments

Compliments should be in every caregiver's bag of tricks. You can stop an unwanted behavior with a compliment and you can help a person out of her funk by talking about her unique talents. You may even be able to get her into the shower by complementing her on how well she has always taken care of herself, even if it's been years since this was the case. You may want to add that you'll do your best to live up to her standards.

I'm sure you would agree that the world would be a gentler and kinder place if we would spend less energy on criticizing and more on complimenting each other on our strengths. When we convene the group in the mornings, we'll greet everyone with a short remark to boost their spirits. "Geraldine, that shirt is such a good color for you." "David, so glad you could make it today. It's not the same without you." It's about recognizing our unique personhood and acknowledging how important each member is to the group.

Rosamund was a perfectionist. We would often turn to her when we needed precise cutting. She could spend all morning sorting our supplies and cleaning up the crafts cabinet.

However, when things didn't go well for her, she would get very upset with herself. She was quite vocal when things weren't going the way she expected. Her agitation soon affected the whole group. When this happened, I'd bring her a "fiddle box" We got used to diverting her by asking her to help sort something out. In her case it always worked, because we could be totally sincere when we'd say, "Rosamund, you are the best organizer and I always appreciate your help."

Humor

Dementia may cause many people to lose their memory and they may be confused about a lot of things in their lives, however they generally retain a healthy sense of humor — provided they had it in the first place. Laughter's really good for our health, and it's crucial for anybody involved in caregiving, whether giving or receiving. Laughter, giggles, and chuckles are healthy for us because they help us relax, improve our heart health and take the pressure off when folks have difficulty with expressing themselves. Try to infuse your daily routines with a light spirit. You'll find that the most fluid conversations happen when people have a chance to laugh or sing and are forget about their aphasia. A funny story will break the ice anytime. It's particularly important that we can laugh together.

We try to get in a few minutes of humor every time we get together. I maintain a growing collection of funny sayings and jokes. Favorites over many years have been *Stupid Laws* and quotes from folks like *Zsa Zsa Gabor* and *George Burns*.

This material can come in handy when you need an instant diversion. Example: In Florida it's illegal to shower naked. (from *Stupid Laws*) - When Molly is giving you a really hard time about her bath; you may be able to distract her from her protestations by interjecting: "Good thing we're not in Florida where it's against the law to shower naked"

And one-liners:

"We divorced over religious differences. He thought he was God and I didn't."

A couple of my own favorite resources are "The Laugh Book" – old vaudeville jokes re-written for children — and "Disorder in the Courts", a collection of actual exchanges in court proceedings, compiled by court reporters.
What follows are a few examples:

Attorney: What is your date of birth?
Witness: July 18th.
Attorney: What year?
Witness: Every year.

Attorney: Your 42-year old son, the one who's living with you, how old is he?

Attorney: Well, doctor, is it true that when a person dies in his sleep, he doesn't know about it until morning?

You might look up other websites with more funny true quotes: classified ads, newspaper headlines, labels, product safety warnings, personals, things kids said , etc.

Never Argue, Scold or Criticize

Very simply: arguing doesn't work. Period! This is true in all relationships, but it's particularly true in our relationships with people made vulnerable by dementia. There's no way a memory-impaired person can hold up his end in an argument, so his choices are limited to withdrawing into a shell, becoming agitated or even striking back physically. It's counterproductive of course and it most likely will escalate your issues because it's doubly difficult to pull a person out of his withdrawn or agitated state.

Admonishing or correcting someone is demeaning and insulting to any of a futile exercise and usually us. Just like arguing pushes a person away from you, admonishing will widen the gulf between you and make your task doubly difficult.

"Don't do that," an auto-response that's very hard for us to drop. Even if your resident is pouring her milk all over her fish filet, plate and table, try to find a response other than this admonishment. - And you'll probably make a mental note to serve her drink separately from the rest of the meal.

"I already told you ten times" implies that there's something really wrong with that person. Once again, let's imagine being in his shoes. How would this feel?

I've also overheard caregivers, both professional and family member accuse a person of *acting like a baby.*

Avoid: "Do you remember?"

Asking a memory-impaired person this question may be like asking a vision-impaired person, "You see this?" If you start a conversation with: "Do you remember?" — the response may be "No" or simply a blank stare. It stands to reason that this question might put off a person with memory issues and bring the conversation to an abrupt halt. All you were trying to do was to have a pleasant banter and reminisce. You had a particular shared experience in mind. There's absolutely nothing wrong with wanting to share a memory, but instead of asking a direct question, start talking about what **you** remember. If your story appears to bring pleasure, you can tell it repeatedly, perfecting your storytelling technique in the process. The beauty of this disease is that it allows your listener to have wonderful experiences over and over again through your narrations, especially when she's an important element in the tale.

In my opinion we put too much stock in our memories and academic knowledge. You may have heard the saying: *without your memory, you're nothing*. This is so not true. A person with Alzheimer's still retains his personhood although he may appear changed to those around him. There's typically a tipping point in the disease when he has lost so much of his memory that he's able to live in the moment and may have the time of his life.

Six of us were having a conversation at lunch about what everyone enjoyed doing. **Connie** took me aback when she suggested that we hold a lecture series. When I asked her if she had favorite subjects, she said she didn't care, since she probably wouldn't remember anyway, she just wanted to hear something serious, real, and grown-up.

I think we need to remember that some of us may recall specifics for years while others like Connie will forget almost immediately but that does not mean that we don't all deserve intellectual and mental stimulation.

Use with care: "Do you want?"

Choices are good; they help boost a person's self esteem, but a memory-impaired person needs to be able to **see** the choices. A good way to start the day is holding up two shirts and ask, "Which one would you like to wear? This red one or the blue one?" She can then simply point to her choice. Whichever she chose, you can throw in a bonus compliment, "Excellent choice. This color looks so good on you; it makes your eyes sparkle." Making choices is very important in retaining a person's sense of self-control.

Many facilities offer their residents menus with a couple of alternatives of entrees. It's always good to offer choices. The problem arises when wait-staff will take orders as much as an hour before the meal is served. A resident will most likely have completely forgotten what she had ordered in the first place, so when the plate is set down in front of her, she may protest that it's the wrong order.

It's so easy to eliminate this problem. Stop taking orders ahead of time. Instead, once the food is ready, have staff bring out the options for that meal, either on a rolling cart* or one plate in each hand. Let the residents point to their choices and hand over that plate immediately.

*Restaurants will often present their desserts on trays or carts. If it works with puddings, cakes, and cookies, it should work with other types of meals as well.

Avoid using the word "NO!"

None of us appreciate being told NO, unless we're getting the results of a blood test for conditions we're worried about. If we're told "No" to a request for something we desire. Just think back to your childhood. "No" might have felt like a serious rejection — or a challenge of defiance, depending on your age at the time. Now that we are adults, most of us have learned to suppress those primal feelings. However, the childhood gut-reactions are still there and when we develop dementia they may resurface.

When a vulnerable person makes a high-risk move, many of us would automatically yell at her to stop with a loud "**NO!**" It's risky when it involves a confused individual. His action likely makes perfect sense to him, so if you yell "**STOP!**" or "**NO!**" he will have no idea *what* he's supposed to stop. Unfortunately this reflex reaction on our part often exasperates the situation.

Elvira was still in the earlier stage of her dementia. Very early in my career, before I understood the intricacies of these disorders or realized that Elvira was living with dementia, I'd come to visit her in her small apartment. This was my third visit. The previous visits had been perfectly pleasant. We had laughed and engaged in delightful conversations, so I didn't think anything of it when she stepped into her kitchenette to make us a cup of tea. We were chatting; I watched from the breakfast bar as she filled the kettle and turned on the stove. That's when things started going haywire. Instead of the kettle, she put a potholder on the burner. My insides screamed "*NO, NO, NO!*" but fortunately instincts kicked in; instead I flew into the kitchen, yanked the flaming potholder off the burner and pitched it into the sink, while I put my arm around her shoulders and with all the calm that I could muster, I changed to subject away from tea, kettles and gas burners.

"*No*" runs the risk of achieving one or two things right away: alienating or pushing a person away or even worse, it can startle her so that she can't think straight and may exacerbate the action you were trying to halt.

Loving Lies and Altered Realities

Altered reality is a term I use when a residents is reliving events from the past, usually the distant past. As your resident loses her short-term memory and most of her other more recent recollections are too fractured to make sense to her, the only memories that are somewhat intact are usually from her childhood and very early adulthood. When she slips into one of these early memories, her experience is different from ours when you and I recall something.

Loving Lies: It's important for us to understand that she's not remembering the way most of us recall something. We are aware that this is something that occurred a long time ago, but to her it's happening right now. Alzheimer's has changed her perception of time and space. She relives her memory with as much veracity as she experiences the here-and-now. The present and the past overlap and commingle. It's counterproductive to try to convince her that she's *just remembering* something. Instead, join in her experience and do or say whatever is necessary to connect with her or help her, especially if she's reliving something disturbing. Remember that this is her reality and your *loving lie* will be her truth at the moment.

These time slips often happen without warning. From observations over the years, I feel that these shifts into altered realities happen particularly at these times:

• She's trying to follow a conversation and something that's mentioned:

 A word, a name, or a phrase that rings a bell from the past.

• Her body clock has been activated. (See *Marge* below)
• She's hungry, tired, bored, or aching.
• She's confused about something in her environment

Marge had just been moved to the Alzheimer's wing from upstairs in the facility. No attempt had been made to help her transition from the freedom of her own apartment into this restrictive environment. She recognized right away that it was a secure (= locked) unit and she was understandably upset. By mid-afternoon she

was at the locked door trying in vain to work the code on the keypad. When her attempts failed she started pounding on the door and yelling for someone to open it. She had finally collapsed into a pile on the floor, sobbing.

It's pretty common for newcomers to be upset in new and unfamiliar surroundings, if they have not had proper transitioning. So staff didn't think much of it. They tried to calm her down and coerce her back into the common room with no luck. Finally two aides dragged her away from the door. Once they had her seated, it took considerable time and effort from both of them to calm her down.

During the day Marge continued to adjust quite well. She was by nature a social person and during that first week, she was quick to make friends with the other residents. However, by mid-afternoon she was back at the locked door and her agitation had increased. Because the outbursts happened in the afternoon staff dismissed it as *sundowning* and tried to distract her the best they knew how.

A conversation with her daughter revealed that when her children were young, Marge would pick them up from school every afternoon. This information certainly explained her outbursts. We suspected that the stress of the move had activated her old body clock and sent her into this *altered reality*. In her mind, she was a young mother and her children were stranded in front of the school and this locked exit was preventing her from reaching them. No wonder she was panic-stricken and hysterical.

The Solution:

Once we understood Marge's history, it didn't take long for us to come up with the perfect *loving lie*. The following afternoon when Marge was once again pounding on the door, we told her that her friend had called just then to say that she would pick up all the children from school today. Marge reacted with immediate relief, reverted back to her "present" self, and readily accepted our invitation to join the others in a cup of tea. We used our *loving lie* for the next couple of weeks until one afternoon when she seemed to have forgotten all about the school, the children, and the exit door. I took this as a sign that she finally felt safe in her new environment.

Sam still appeared entirely lucid and reasonable. You'd be likely to question why he needed to live in a secured memory care unit. He enjoyed long and intricate conversations but might suddenly blurt out a remark completely out of context. One day in the middle of such a chat he mentioned that the skeletons were still visiting in his room at night. Of course I asked him to talk about them. He wasn't scared, he said, but rather a bit annoyed because they glowed in the dark and he couldn't understand what they were saying and even how they could talk since they had no vocal cords. After discussing this with him for a bit, I suggested it might be worth trying to hang a sign to hang in his room that said, "Skeletons not welcome here. Go away." Sam most likely had Lewy Bodies dementia. His hallucinations were not limited to night visions. One day, he apparently saw a beach in place of the nurse's station and at another time, the patio outside the dining room window had turned into a riding stable for him. In Sam's case, he reported that the number of skeletons that visited him at night had declined, so maybe the sign was working.

Robert had been a prisoner of war in the Korean conflict. Once in a while, something would spook him and he would suddenly go into a panic state. He was convinced that *they* were coming for him. Was he "reliving" actual events as an altered reality or was he having hallucinations? We never knew just which, but it didn't matter. Our only mission at those times was to help him feel safe again. At first we told him that we were here to help him and we wouldn't let anything bad happen to him. That did not appear to satisfy him, so we had to come up with something much more authoritarian. We disabled the phone and while he watched, we pretended to make calls to CIA, FBI, and military police, "confirming" that they had secured the perimeter and that they had just confirmed that Robert's whereabouts were top-secret. As long as we maintained a serious tone and a sense of urgency, Robert accepted our ruse and calmed down.

It's important that we understand that although they may not show it, memory-impaired persons react more intensely to their bad feelings and are often not able to work themselves out of an emotionally painful state without our help.

In Robert's case, we needed first to validate his anxiety and as soon as he seemed to have regained his equilibrium, to help him find something interesting to do. He decided to join a group in a lively discussion.

Theresa had just been moved from assisted living when I met her in the doorway. As I opened the door to enter the secure memory-care wing, I came face-to-face with her as she tried to push her way around me to get out. Fortunately, I'd had similar situations many times before over the years, so I managed to coerce her back from the door. The staff then told me that Theresa's attempts to leave were a persistent issue and they were at a loss. She had been moved into memory care a few days earlier because of her propensity to leave anytime she had a chance. Apparently, nobody had attempted to learn why she wanted to leave.

A short conversation with her daughter revealed that Theresa had been a nurse her entire adult life and she'd been very good at it. Her "escapes" were likely attempts to get to her job at the hospital. Focusing on her strengths, we told her that we sure could use her help. We got her a clipboard and pen, made copies of the standard charts and asked her to help out with the regular checkups. Later we ordered an official looking name tag designating her as assistant nurse. This changed everything, she calmed down, her demeanor changed and she settled in happily.

A Picnic

It was a gorgeous day in the late spring, so we packed a picnic lunch and headed out to Glorieta, a beautiful setting in the woods of majestic pines.

The picnic area overlooks a large pond. We chose a table in the shade of the Scottish pines and took in the idyllic scene. On the opposite shore, a group of children were throwing beach balls; ducks noisily gobbled up breadcrumbs tossed to them by a young couple at water's edge. Several people were on the water in paddle-boats. It was pure nostalgia, reminiscent of a Claude Monet painting!

My three companions were all in the later stages of Alzheimer's with practically no short-term memory, but still very much able to enjoy and be aware of the experiences of the moment. It's not that common for people at this stage of the disease to converse, however the three of them were chatting with delight. I simply listened, not wanting to disrupt the harmony and their enthusiastic banter. I realized that the nostalgic scene before us had transported all three back in time and they were all reliving memorable events in their individual childhoods.

I was quite familiar with their backgrounds through their lively conversations about childhoods, most memorable Christmases, best cookie recipes, and games they'd play on childhood outings. Now, listening to them, I could tell that Joe was definitely at a family picnic in the mountains, — most likely the Catskills, since he was a New Yorker. Sue appeared to be at a big gathering in a favorite park area on the shores of the Lake Erie and Phyllis was somewhere at San Francisco Bay. Since they were *reliving* these events rather than remembering, each one of them assumed that the other two were sharing their experiences. I simply sat back and listened in fascination. Although the conversations were quickly forgotten and the trip itself soon was a vague uncertain memory, their feelings of elation lasted all the way home and into the next day. People in mid-to late-stage dementia may forget details but their feelings linger for a long time. We now recognize that feelings linger particular long in people with cognitive impairment. This appears to be the case with both good and bad feelings.

A Wedding

Charlotte was a resident in the Alzheimer's wing of the facility where my friend Paul was activity director. Paul shared with me this *altered reality* experience.

Charlotte was having growing difficulties with communication and was increasingly withdrawing into her own world. Since she had first moved into the nursing home, she had gone from one obsession to another. At one point, she had fixated on germs — on her clothes, in her food, and on anybody who might touch her. At another time it was something outside one particular window visible only to her. Her fixations usually lasted only long enough for the staff to readjust their approaches to her "reality du jour."

However one obsession took hold of her and had grown more intense as time went on. It had seemed innocuous at first. Charlotte parked herself daily on a bench near the entrance. Whenever the doorbell rang, she would perk up. However when the visitor apparently was not the one she had expected she'd sink into noticeable disappointment. Over the weeks Charlotte spirit turned from sadness to grief and despair. She was increasingly seen weeping. Staff decided they had to do something. Because of her difficulties with communication, it took a concerted effort for them to discern that Charlotte's vigil at the door was for her beloved, who had assured her that he would be there any day now to marry her.

A conversation with her niece revealed that Charlotte had in fact never married and the niece had never heard of a pending or failed wedding. None of this made any sense. They speculated that her sweetheart had gone off to war and never returned. Charlotte wasn't able to tell them anything beyond: "He's coming soon and then we'll be married." (Or at least the aides were pretty sure that's what she said.)

The staff tried all kinds of diversions: They cajoled, flattered, and tried to entice her with cookies and songs, but to no avail. Charlotte remained indifferent to their efforts. The niece took her out to twice as many lunches as before, but as soon as they returned, Charlotte would resume her brooding vigil at the door. She changed. She had always been gentle and cooperative in spite of her obsessions and hallucinations. Now she was frequently agitated and obstinate.

Drastic measures were needed.
Paul decided they would have to celebrate her "wedding." The staff readily committed to help make this happen. At a local thrift store, Paul found a wedding gown that promised a reasonably good fit. One of the nurses brought a bouquet of silk flowers from the front lobby. On the designated day, the staff rearranged the furniture and decorated the dining room, the kitchen baked a tiered "wedding" cake and family members, who happened to be visiting at the moment, were recruited to stay on as "wedding guests."

Staff made sure that all the residents were dressed in their Sunday best.
Everything was in place except for the fiancé. What to do? So Paul decided to act as the stand-in for the groom. He pinned a showy white silk rose to the lapel of his coat. One of the other residents, a retired organist, played a pretty good simile of the wedding march. The bride beamed in all her finery as she was walked down the "aisle," on the arm of the cook. The janitor, a long scarf draped around his neck, performed the "ceremony." It was a glorious affair. The reception was the best party the nursing home had had in ages, — if not ever. Charlotte basked in the spotlight for the rest of the afternoon.

By the next morning Charlotte seemingly had forgotten everything, but her demeanor had changed; she was calm and unperturbed. She didn't once go near the entrance. The subjects of fiancés and weddings never came up again. Nobody ever learned what event in Charlotte's life had bubbled to the surface because of the disease — or if this had been a pure fantasy. But thanks to Paul's creativity, it apparently had been resolved for Charlotte. She was back to her contented and gentle self.

Agitation

The physical and chemical changes in the brains of people with Alzheimer's affect comprehension and memory as well as mood, energy and spirit. That person is more susceptible to outside stimuli and has less control over his emotions. Feelings, good and bad, linger much longer in people with dementia and Alzheimer's. When we experience sadness or grief, most of us are able to reason ourselves out of our blues and our strong feelings fade pretty quickly. People with dementia no longer possess this ability. For them these feelings last a lot longer, often unchanged in intensity. Sadness and anger tend to linger longer than happy and joyful feelings. With that in mind, you can see the importance of maintaining a positive atmosphere and be aware of behavioral expressions.

It's one thing to understand logically what's happening, quite another to deal with your own emotions. Outbursts can feel like personal attacks, and yet it's important not to take any of them personally. This important piece of advice sounds a lot easier than it is for most of us:

DON'T REACT TO THE ATTACKS,
don't justify or explain, and don't try to reason
–And above all, ***DON'T ARGUE!***

Reacting or arguing will only escalate and prolong the conflict. Instead, quickly change the subject to something unrelated to the subject of his rage. Try to remember that it's the disease acting out and do your best to change the situation into something positive. When he has one of his outbursts, you may want to validate his anxiety with a simple remark: "It sounds like you're really upset." But before his agitation escalates even more, offer him an irresistible distraction. This could be a bowl of ice cream, a walk, — or an activity. He may need an ego-booster right now, so whatever you choose find something on which you can compliment him. Anything that needs to be sorted works particularly well in these situations. Hand it to him and say, "See what I just found. You're much better than me at sorting stuff; would you mind looking at this?"

If this is a particularly intense confrontation — or if your first attempt at distracting him fails, pretend that you must use the bathroom immediately and exit the room. A few minutes later return with a big smile and positive demeanor as you pretend that you just arrived and have something wonderful to share.

A couple of typical scenarios and suggestions on how to handle them:

He mentions a particular gadget and yells at you, "Where is it? It's mine! You stole it!" This particular item was thrown out years ago, but if you try to convince him of that, he won't believe you and you'll probably only agitate him even more. Instead, you may answer like this, *"I'm right in the middle of something, but if you can wait a few minutes I'll be glad to help you look for it. - While I finish up her, would you mind holding this box for me?"* You have giving him validation, but immediately distracted him with something to do: holding a *fiddle box.*

Another scenario:
You left the room for a few minutes and when you return, he greets you with an accusation: *"Where have you been? Why did you leave me here all alone? You said you'd be right back. You lied."*

People with Alzheimer's and other dementias often lose the sense of time and space; when you've been out of sight, he may not be able to gauge how long you've been gone. Two minutes may feel like an hour to him. However trying to "set him straight" is an exercise in futility. Instead, you may simply say, *"I'm sorry I took so long. I'm so glad you waited for me. Thank you. (And then the diversion) – I could use a snack right about now. You want to keep me company?"*

In both situations you've deflected his anxiety without accusing him of being wrong. Thus you have maintained his dignity. As much as possible use compliments and let him know that you're happy to be there with him. With practice, this approach will become second nature to you.

Behavioral Expressions

Dementia can easily be an emotional rollercoaster for everyone involved, whether they're living with the disease or they are caregivers or family members. Families are baffled by the changes they observe in their loved ones. They may do their best to adapt and lend their support, but none of us is truly prepared to deal with a disease this unpredictable.

In addition to the possible physical changes brought on by the progression, many persons living with dementia of the Alzheimer's type will experience a phenomenon known as aphasia, leading to increasing difficulty in expressing themselves. This usually involves mispronouncing words, difficulty with finding the right words or using odd substitutions. One of our residents used the word *legal* in place of any word or name she'd forgotten; we got pretty good at figuring out what she was talking about.

The other side of aphasia is experienced by the person herself. Just imagine how you would feel if you couldn't find the words to express yourself. What would you do if you felt it was an emergency situation your aphasia was so bad now that you only have a few words left, the rest of your communication is in odd sounds and gestures?

Let's say a new staff member tells you she's taking you to a shower because it's on the schedule for today. She takes you by the arm and turns in the direction of the bathroom. You resist because this person's a complete stranger to you. You try to object, but because of the aphasia you cannot make her understand that you're not going. She has a pretty tight grip on your arm as she tries to drag you toward the bathroom. What would you do? My guess is that your reaction would be the same as most people in that situation. You'd try to pull away and cry out for help. When nobody comes to your rescue and she won't let go of your arm, you'd eventually strike out at her to stop her from dragging you. Now, if you are living in a care facility, at this point, you'd be considered a "behavior problem — with vio-

lent tendencies." An incident report will be written up on you. The nurse will consult with your family about a medication to "control your behavior."

This scenario is not unusual in our care facilities, even at very respectable facilities that take pride in the care they offer their residents. Fortunately, there's a growing awareness of "behavioral expression," the concept that a person who can no longer verbalize will try everything to make themselves understood, through gestures, curses, loud noises, or other displays that may be interpreted as agitation, anguish, or anger. We're too quick to assume that people with dementia will be aggressive or violent at some point in their disease. It may as simple as our not understanding what that person is trying to tell us.

So, what should we do?

Until we see major changes to our systems, we'll have to do what we can as individuals. If this is happening to you or your loved one, before you approve any new medications, I suggest you tell the facility that you need to meet with the people involved and that you'll ask your local Ombudsman to join as a witness and mediator. Without blaming anyone, ask for details of the incident: Who said what? And who did what? What does everyone think your loved one was reacting to or what was she attempting to express with her behavior? If they declare that she was simply angry, let them know that you know that something happened to make her feel that way and remind them that sometimes with her loss of speech, her reaction may be the only way she can express herself. I understand that this can be a very difficult conversation to have, but try your best to stay calm and refrain from accusations. This will probably be easier, if you keep in mind that most professionals don't recognize this. I hope the result of your conversation will lead to greater awareness on everyone's part of nonverbal communication.

One of our residents had struck a nurse. Nobody had taken the time to learn what had caused this otherwise gentle soul to react to violently.

"I want to go home!"

There are some scenarios that are common to all care communities, from the lowliest nursing home to the fanciest private pay facility. With very few exceptions, residents didn't have much say in moving here. Some of the questions that are familiar to all staff members are: "What am I doing here?" — "Where am I?" — and in the case of some "secure" or locked units, you might even hear: "What did I do wrong?"

And the most common plea: "I want to go home." This may have little to do with an actual location. The resident has lost her independence and freedom and she's feeling loss and anxiety at being in unfamiliar surroundings. She may be thinking of her most recent home or, on the other hand, she may be alluding to her childhood home. Your reactions should be the same, either way. Your aim is to help her feel at home, i.e., *Emotionally safe*. She'll probably adjust in time, but in the meantime you'll have a better chance to gain her trust if you tell her how glad you are that she's *visiting* with you and that you're lucky, because you're really happy to get to know her. If she continues to obsess about her own home, acknowledge her feelings, but don't linger on the topic; instead, try talking about things that she used to do in her home: You've heard that she's a great gardener (cook, ironer, silver polisher or whatever) and how you could use her help with some of those things while she's *staying* with you. Then, use it as a lead-in to a diversion: "I think this conversation deserves *a cup of tea.* How about you?" or — "I'd like you to join me for a walk," — "I'd like you to read this new magazine with me," — "I'd like you to help me with the cookies" — (or whatever fits the moment). The point of this exchange is to help her feel included, safe, and validated.

Many a resident was moved out of her house after it became clear that it was no longer safe for her to live on her own. She wasn't eating right and usually spent the day in a nightgown. She no longer bathed or cleaned her house. It was obviously a necessary move and she ought to be happy that she was rescued, right? But she doesn't see it like that. As far as she's concerned, she was doing just fine in her own house and she gets very upset when we tell her that she could no longer take care of herself and therefore she's *living here* now. It takes a while for any of us to feel at home in a new place and is a lot harder for a person with serious memory issues.

We can help people transition into this new environment. First we need to be aware of impact of our communication. *Living here* feels permanent and irrevocable. Try to replace it with *Staying here. Staying* is temporary and could mean a weekend or 10 years. It helps us to remember that leaving home and losing one's independence is as devastating as losing a loved one, and in this case your resident had no say in what happened to her.

If her home was sold to pay for her care, it's a topic best left alone. I've heard well-meaning family members, determined to *tell the truth,* say, "Your house was sold, so you can't go home." That truth can be so devastating that it may plunge a person into a deeper state of dementia and possibly bring on depression as well. It might help the family to sit in on care management meetings. It's important for everyone involved to understand the importance of using the same *loving lies.* If she asks directly about her house, you can tell her that everything is fine and someone you trust is taking care of it while she's *staying* here.

Lili had lived in our facility for over seven years and yet she continued to believe that she's simply *visiting*. One of our routine conversations would go like this:

> Me: Lili, we sure had a great time today. I'll see you in a few days.
>
> Lili: Probably not. I'm going home tomorrow.
>
> Me: Well, I hope to see you again before you go, okay?

Sometimes Lili would add that she's had a very pleasant stay at this nice "hotel" – Nobody told her otherwise.

Sundowning or Body Clocks?

Many of us are sensitive to the waning light in late afternoon. When this affects people with Alzheimer's or related dementias, it's known as *sundown syndrome* or *sundowning.* In some cases *sundowning* causes agitation, a change in personality, or increased confusion. In cases of serious agitation diagnosed as *sundowning*, it is quite common to prescribe an anti-anxiety medication. Before we medicate people to change their behavior, I believe we need to explore other possibilities. In my experience more often than not, these behaviors have been reactions to people's internal body clocks possibly brought on by the waning light in the late afternoon.

Body Clocks.

We all have more or less active body clocks. We wake up a few minutes before the alarm goes off — or we get antsy at dinnertime, whether we're hungry or not. Most of us spend most of our lives in regular routines. Just because a person has "retired" from a job that she held most of her life, doesn't necessarily mean her body is aware of her new life at leisure, so when it's close to her old *quitting time* she may have the urge to go home, or she may not feel complete until she has *closed the books, cleaned up her desk,* or *punched out.*

When the person in your care exhibits changes in her behavior in the late afternoon, I recommend that you explore the possibility that she's reacting to old body clock impulses. Rather than assuming this to be *sundowning.* If you cannot identify an exact cause, try to use a diversion that relates to her former life: If she worked in an office, you can hand her a few files to organize or if she worked in

retail give her a cash box with change to be counted. Whether or not she actually engages in the project, be sure to thank her for her help.

The following situations illustrate how easily body clock reactions can be interpreted as *sundowning*:

Ruth cheerfully participated in our activities. However, around 4 o'clock in the afternoon her personality changed. On better days she would simply be sullen and distant; on the worst days she would become restless, fidgety, and agitated, sometimes to the point of tears. This had been going on for weeks and everyone assumed that she was *sundowning* and beyond our help. We tried to distract her by getting her involved in activities. It might work for a few minutes, but before long she would be back pacing, usually around the serving counter in the kitchen area. Our common room, which also served as a dining room, was a converted apartment, so it had a kitchenette with a breakfast bar but all the meals were prepared in the main kitchen and brought down to us on individual plates. Ruth's agitation was primarily focused on the empty kitchen.

Because Ruth's behavior was so consistent, we decided to explore the body clock possibility. We learned that her husband was a stickler for rigid schedules and during the fifty-plus years of their marriage Ruth had served dinner daily at six o'clock sharp. Her agitation made sense. Ruth's body clock was on *"dinner fixing"* time. In her mind she needed to prepare the meal and there was nothing for her to work with. Ideally, we would have asked Ruth to help with food preparation, but unfortunately all the meals arrived fully prepared in the central kitchen. We did ask her to help set the table, but that only worked to accelerate her agitation. — We needed to find a solution.

Loving Lie:

We told Ruth that someone else was doing the cooking tonight, because she deserved a day off after all those years of making dinner every single night. She accepted our story with no hesitation. She welcomed the break, which was understandable; apparently her husband was quite controlling, including over her household.

Once we understood the reasons for Ruth's anxiety, we initiated preventative action. As soon as her demeanor started to shift, we would ask for her help in planning tomorrow's menu, while reminding her that she could take tonight off. Ruth's daughter got involved in our project as well. She brought gourmet magazines, a cookbook and a recipe file box. The two of them would find a corner table and talk up a storm. She helped Ruth write recipes on her index cards and cut out pictures of impossible delectables, which we kept in a portfolio (a manila folder with her name on it).

After Ruth's passing, her daughter thanked us for giving her the best couple of years with her mom. Before the recipe project, it had been so hard for her to visit her beloved mother because she hadn't known what to talk about, which had been a constant reminder that her mother was fading away. Sharing something that they both genuinely enjoyed had brought back so much of the mom she used to know.

Memory or Fantasy?

Every case of dementia is unique. For some people the decline is pretty steady, while many others experience a great deal of fluctuations and sudden declines followed by plateaus. One day a person appears pretty normal, the next she may not recognize even the most familiar. This can be most disconcerting to family members. An otherwise loving wife may suddenly think that her husband of forty years is a dangerous intruder and try to chase him out of the house with a frying pan.

There's no predicting which memory will surface or vanish at any particular moment. She may suddenly have forgotten something that you reasonably considered totally familiar. Maybe she refuses to go to a store right down the street, telling you she doesn't know where it is. This is the same store where she has shopped for thirty years, so you may think she's lying to you or simply because she's lazy and doesn't want to get out of her chair.

She can likely tell by your tone that she *should* know the answer, a realization that is probably upsetting to her. If you persist, she may get quite agitated or depressed and the rest of your day is easily ruined. However, if you start with the assumption that she's not trying to deceive you, but rather it's the disease surfacing, It will make life so much better for both of you. Take a few moments to sit with her, share an ice-tea or some grapes and some good girl-talk. - *Rule of thumb: stress leads to confusion and memory loss.*

Ellen was a tall, elegant, and well-educated person. She used to be a wonderful conversationalist, but Alzheimer's now fractures her train of thought. She still loves to chat, but she jumps from one topic to another and makes no sense a lot of the time. Short-term memory loss means she cannot remember from a few minutes ago. It's a physical phenomenon - The *hippocampus* is the receptor of new impressions and the center of creating new memories. As the disease progresses, this organ starts to disintegrate, recent memories are hit or miss, however old memories are stored elsewhere in the brain. The disease does erode these centers slowly over time, but for most of the duration of the disease, memories from a

person's childhood or early years stay intact. In other words, we could say that our memories are erased or deleted in reverse order as the disease progresses.

Reliving rather than recalling. It's important that we understand that a person in the advanced stages of the disease will *relive* rather than simply *remember* an early episode. Whatever is happening to her feels completely real to her.

An imagined conversation between Ellen and her daughter Judy:

Judy: We should call Caroline about the party.

Ellen: (has no recollection of a party or who Caroline is) Is my mother coming? ("party" has triggered a childhood memory).

Judy: What? Oh, Mom! You know that Grandma's dead.

Ellen: (still back in her childhood) Nobody told me. (quivering voice) Why didn't someone tell me?

Judy: She's been gone for years, don't you remember?

Ellen: I want to go home. (Tears welling up)

Judy: You *are* home. You *live* here with me.

Ellen: I want to go home. Take me home.

At this point Ellen is inconsolable.

Now, imagine how differently the conversation between Judy and Ellen if Judy understood that Ellen had gone back in time. Try to read this again from Ellen's point of view and her reality at the moment.

Judy could have helped her mother by simply rephrasing one sentence:

Instead of: You *are* home. You *live* here with me. (Heard as: "This is it! You have no say in the matter. You're stuck here")

Judy could have said: You're *staying* here with me.

Especially if she'd added: And I'm so glad I get to spend time with you.

Activities

Purposeful and Stimulating Programs

Most state regulations require care facilities to post monthly schedules of activities. Often these schedules are broken into one-hour blocks (reminiscent of our school-days)? This makes life easier for staff, however it also limits resident input, spontaneity, and individual creativity.

It can be a challenge to come up with a balanced and diverse program that will engage as many of our residents as possible. The following list is a good guide to establish a balance in your offerings.

Passive: <u>listening</u> to music, <u>watching</u> TV, going on sightseeing trips

Active group projects: exercising, singing, dancing, walking, gardening, cooking, making art

Intellectual stimulation: Lectures, conversing, reading, writing, discussions

Creativity: Arts and crafts, poetry reading and writing, storytelling

Game playing: Ball tossing, croquet, Nerf basketball, Nerf bowling

Social: Teatime, garden parties, fashion shows,

Laughter and fun: Crucial! If we don't enjoy ourselves, it's not worth doing. Our calendars would feature large blocks of time, i.e., from breakfast to lunch and all afternoon until dinner time. This open schedule gave everyone time to explore at their own pace. When it was time to put together the "official" monthly schedules, I'd invite any of the residents to help out. We'd spend part of a morning coming up with titles that were so vague that they could stand for anything. The exceptions were when we had arranged for performers or visiting artists.

Other than those preplanned events, we wanted to keep our options open because there was no way to predict where our projects would take us.

It's important to our success that we listen to the wishes and suggestions of residents. After all, we design these projects to improve their lives, not for our convenience or our own satisfaction, although it helps if we enjoy the activities as well.

Our participants may find satisfaction in exploring for its own sake or possibly find to a new purpose, such as painting, gardening, setting tables. Many of our residents would return to their favorite projects daily for months. As an example, Burda would spend all morning with her own fiddle box, arranging and rearranging her fabric swatches.

I hope you encourage all your residents to participate in the planning of your programs. It may be difficult to do this is a group setting, but you can weave your questions into your regular conversations. They may not remember their input, but you can honestly say that something was Phil's idea, or Norma's or the group's idea. - And please thank them for their ideas.

Suggestion when you work on your programs, in addition to interesting activities that stimulate the body and brain, we also consider the senses:

Hearing:	Music, poetry, and conversations
Taste:	Food and drink
Smell:	Scented oils, fresh flowers, garden soil
Touch:	Fiddle boxes and bags, balls of yarn, clay
Sight:	Art projects, outings

This list is what immediately comes to mind for me. You'll likely have your own.

Our Typical Day

As a teacher, I made a point of acknowledging every student. I brought this habit into my work with this population. I introduce myself and greet everyone with a brief compliment every morning. This has two purposes: a safe way to eliminate possible embarrassment for those who have forgotten my name and along with acknowledging each individual, we're reaffirming our connections as a group — or eventually, a family. I recommend that you try it as well.

We gather in a circle and start the day with an upbeat song, i.e., "Hail, Hail, the Gang's All Here" "Zippy Dee Doo Dah," "Oh, What a Beautiful Morning," or "You are My Sunshine." This short ritual brings everyone together and sets the tone for the rest of the morning. We do a short exercise session, "marching" to a silly song, dancing, or most often, *Sittercises.* The rest of the morning is taken up by various projects, laughter and chatter.

Often we have one major project going (tile painting absorbed most of the group for more than three months). But there are always others available for those who so choose. This population might have problems organizing themselves and of course they have problems with memory, but once the pressure of the clock is lifted (free-flowing programming) even people in the advanced stages of dementia are capable of learning new skills and becoming quite proficient in handling new tools. By being free to work as often and as long as they wish, they reach the point of "owning" the medium (understanding how things work) and can concentrate on creating. We'd always have people who prefer to explore by themselves, with fiddle boxes, portfolios, leafing through an art magazine, or simply organizing stuff.

After lunch, some might return to their projects. At least once a week, we'll have an ice-cream social or teatime with the good china and cookies. When the weather's good, we often take our activities outside or go on outings. Otherwise we'll a variety of choices, including those featured here. We often finish the day with a full sing-along, story or joke-telling session or socialize with a getting-to-know-you, where we would share our likes and dislikes, favorites (cars, cookies, comics or)?

Edith was a very energetic and enthusiastic participant in everything we did. She was usually the first to set up her project: In the case of her favorite: tile painting, she insisted on two blank tiles, her paper plate palette with her colors for the day — everything lined up, just so! She most often started by painting designs on the "palette" itself and by this time the paint bottles had been handled by others and looked out of order, so she'd get busy rearranging, by shade and tone. She would rarely get around to painting her tiles. We displayed her painted paper plates –a pretty design is valid no matter the medium, right?

Edith was our "cutter" supreme and generously helped others with their collages and other project that required nimble scissor work.

#

One of the favorite destinations for our field trips is *Shidoni,* a large gallery complex that includes a large fine craft gallery, a glass blowing studio, and eight-acre of sculpture gardens that feature outdoor sculptures, many of them the monumental pieces you see in front of banks, town squares, and other public places. Our group of around fifteen of our residents strolled around the garden to view the dozens of large sculptures that ranged from very traditional bronzes to one-of-a-kind assemblages. We had brought sack lunches and when everyone decided that it was time for a rest and nourishment we settled down at a couple of the large picnic tables set up for public use. No sooner we were seated than Donald got back up, and strolled back to examine the assemblages up close, sandwich in

hand. On his way back to our table, he paused by a lonely and sad-looking little tree, pulled the meat out of his sandwich and with great care nestled the two slices of bread into the branches, repositioning them a couple of times. He returned to the picnic table, with a wide happy grin on his face, obviously pleased with his contribution (on the left).

Group Activities

As much as possible we get everyone seated either in a circle or at one big table. In most of my programs we've been fortunate to have rectangular tables that easily lent themselves to being pushed together into one large. Having everyone work close together helps them inspire each other and they also develop and solidify a sense of community.

When we've had to use round tables we'll push them together, even though our "neatniks" may not approve.

1. Ball toss
2. Dancing or chair dancing
3. Making a fruit salad
4. Group collages or wall decorations
5. Make sculptures from found objects
6. Table setting and decorating
7. Arrange cheese and crackers
8. Make flower arrangements
9. Write or tell stories
10. Set the table
11. Decorate cookies
 Tip: Buy extra cookies.
12. Word games
13. Ice cream social
14. Make fruit salad

More ideas in the addendum:
"101 Things to do with Alzheimer's"

Infuse the day with companionship, creativity, and laughter

Activity Centers

We are social beings; we need companionship and shared experiences with others. Most of us prefer sharing a meal at a restaurant or café with other people around rather than being off by ourselves. Likewise, we invite others to join us for holidays, birthdays, weddings or simply to celebrate our friendships. Living in a facility, even in a so-called "memory-care" unit, can be very lonely. Loss of a person's abilities, such as speech and memory, makes it harder for him to reach out and connect to others.

Human beings are not designed to be idle creatures. We need stuff to do. We need purpose. We need to contribute and feel part of our community even as our memory and functions decline. As Alzheimer's takes over, our ability to initiate, reason and think in the abstract is diminished, although our needs don't change. We still need intellectual stimulation. Several of the examples in this book fill some of these needs for people in the advanced stages of the disease and also give caregivers tools to help residents who're bored, agitated or restless. When a resident is occupied by purposeful and enjoyable tasks, her mood is elevated. When she feels better, our burden as her caregivers has lightened a little bit. If we take two minutes to help a resident start a project, it may save us ten-fold in aggravation and interruptions later.

The psychological need for purpose does not change as we age or as our cognition falters. Hence, it's natural for our residents to gather around the nurse's station when there's nothing else to draw their interests. After all, the nurse's station is always the hub of activity. However this attention can be a bit too distracting for the nursing staff. For this reason we designed "Activity Centers" for our Alzheimer's unit. We needed instant access to easy projects that did not depend on organization or someone "directing" an activity. Since our budget was practically nil, it had to be nothing fancy or costly. Scrounging around the facility we came up with almost everything we needed. The rest we picked up at thrift stores.

The staff were skeptical. They envisioned themselves doing double duty. Not only

taking the time to get a resident involved in a center, but having to clean up after her and retrieving items that had found their way to her room. It was a lot easier for staff when the place was void of any loose objects that could be misplaced, but of course that also left residents with nothing to do except to slump in their chairs or get agitated or aggressive.

These centers turned out to be a godsend. Many of the staff saw the benefits for the residents who were happier and more engaged than before. Some staff admitted that their work had been eased because of fewer incidents of behavioral expressions.

Miriam had been driving everyone crazy ever since she moved in, incessantly asking the same questions every few minutes: "Where do I go?" and "What do I need to do now?"

Miriam's daughter described her pride in her long career as an executive secretary. After we set up the activity centers we'd ask her to help in the "office." We'd hand her a stack of files to sort. This kept her occupied for fifteen-twenty minutes at a time and at least staff had a short respite and Miriam felt accomplished, so when she resumed her questions, the urgency in her voice had mellowed.

Two other residents had been career mothers, so both the "nursery" and "kitchen/pantry" were perfect activities for both of them. They'd keep themselves busy folding baby clothes and organizing dishes, canned goods and trays of flatware.

One drawback was that items would often find their way into people's private rooms. At first the staff grumbled when we asked them to help us, but eventually they got used to keeping their eyes peeled for the stray spoon or baby pacifier and bring them back to the activity centers.

Suggestions for Activity Centers

In order for the activity centers to be meaningful to your residents, they must feel real to them and must be treated as such by staff, families, and caregivers.

Boutique: (dress-up corner). An "enclosure" created with a standing screen and displays on the walls (hats, strings of beads, belts), a mirror. Signs to establish the "shop," Racks for clothes, scarves, belts and strings of beads. Avoid items that can cause injury, such as rings and pierced earrings.

Office: Desk, chair, filing drawer, typewriter, adding machine, file box, note pads, hole punch, and a couple of three ring binders. Lots of stuff to be filed and sorted.

Sewing corner: Sewing machine (non-functioning), pattern envelopes, pattern books, lots of fabric swatches, boxes with spools of thread, buttons, zippers, and ribbon remnants. If you worry about someone swallowing buttons, you can string several buttons together.

Kitchen or pantry: Dishes, bowls (plastic), pots and pans; large plastic mixing spoons, plastic cookie cutters, cookbooks and recipe collections. Canned goods to be sorted and stacked. Silverware to be polished. Brooms and dust cloths.

Workshop: PVC pipes, locks, assorted hardware and tools (nothing that can cut, pinch or puncture) Tool catalogs, homebuilding magazines, Popular Mechanics.

Nursery: Baby crib, changing table, high-chair. A cabinet for baby clothes, blankets, bibs, towels and washcloths. Lifelike baby dolls are wonderful but a person with Alzheimer's may pace and be dangerously exhausted carrying an eight-pound infant. I prefer dolls similar to the ones shown here, 16" long with soft bodies and weigh only one pound.

Clubs

Our "memory care" unit had a large population ranging from residents who were still quite high functioning to several in the very advanced Alzheimer's stages. It's difficult to design effective programs for such a wide span of abilities and needs. We ran the risk of having a calendar full of "one-size-fits-all" offerings, which usually end up being very bland and innocuous. Our toughest task was always to find something for our early stage residents, who needed particularly stimulating, challenging, and interesting helpings. This was not the Bingo-three-times-a-week crowd, but rather TED talks, PBS NOVA, and other thought-provoking offerings. We decided to take advantage of the tendency of this demographic to form small groups or cliques. The result was our "Clubs." All of the clubs needed staff involvement initially but it wasn't too long before a lot of the cliques had shifted from primarily gossip sessions to discussions, i.e., "The Players" might start by talking about favorite games and end up talking about mothers, travels or previous jobs. We had to learn not have any expectations or specific goals for these sessions and just go with the flow.

Book Club:

Members discuss their favorite books and authors, listen to audio books or read out loud to each other.

Players' Club:

Members choose, schedule, and play games.

Yarn Club:

A gathering of people who enjoy (or used to enjoy) sewing, knitting, crochet, needlepoint and weaving. All things yarns and needles.

Cooking Club:

Members make salads, snacks, and of course, bake cookies.

Poetry and Writing Club:

Members work together on writing projects, poetry and autobiographies. Members could be encouraged to perform their poetry for the general population.

Theater Club:

Members enjoy short improvisational acting projects (with student volunteers from one of the local schools or colleges)? Possibly give performances and attend local theater productions.

Music Club:

Members come together to listen and discuss different types of music. Also make music of their own, create songbooks, and have sing-alongs.

Special Events Club:

This group invites interesting guests of all sorts: performers and speakers. The special events could also be dances, or simply celebrations.

Garden Club:

Members work on outdoor garden and indoor plants. Members may want to sponsor or host garden parties.

Movie Club:

Members talk about favorite movies, movie stars, memories of going to the movies. They can help select the movies to share with the general population. Assuming your facility has cable or satellite TV service, I recommend that you subscribe to one of the on-demand movie services. You can introduce YouTube selections of favorites such as funny animals, adorable babies, travel videos or favorite performers. One of the all-time favorites of all my groups has been MGM's "That's Entertainment" — which features highlights from many familiar movies.

Projects

Focus on Abilities, not Disabilities

I find it very sad that we tend to treat dementia as something very different from other chronic disabilities, such as diabetes. Most services for people living with dementia focus on their disability, forgetting that most of this population are still able to enjoy the ordinary little distractions of daily life as much as the rest of us.

I learned quickly that dementia may cause short-term memory loss, but leave long term memory pretty much intact for a long time. The same is the case of skills and special abilities learned early on. Several of our residents had problems finding their rooms or getting dressed but might still be able to teach you their special skills. One of our residents was a sample seamstress for a fashion house. She was the best of the best. I met her when her dementia had progressed to the point that she needed a lot of help with ADLs but she still handled the sewing machine like a pro and could guide others as well.

Norma and I had found our groove pretty quickly. She would still have sporadic outbursts, but I soon learned to ignore her momentary fury and reconnect with her by talking about something totally unrelated to whatever had brought on her distress. Her explosions would quickly dissipate and we'd be back on an even keel and in the end we both had a great time. She enjoyed art and loved exploring for interesting and unusual things so we visited museums, the flea market and galleries.

Norma thrived on our outings. She was outgoing and quick to engage strangers, but back at the facility, there was no one to share her joy. The staff was preoccupied and not in the least interested in her excited semi-coherent and disjointed ramblings. The other residents were pretty much locked into their own silent shells. Norma tried valiantly to engage her table-mates at lunch and I saw her disappointment when she failed. I decided to spend more time beyond a couple of hours at a time to help develop her community.

We collected catalogs and announcements from the galleries on our excursions, and soon found ourselves with a big pile of all these beautiful colorful images. Thus started the first collage project. At first we worked in Norma's apartment,

but after a couple of weeks we took the project down to the common area instead. Nobody paid attention the first day, but curiosity soon got the better of a few residents. After all, we were the only action at the time. Slowly people drifted in to join us. Conversations and laughter flowed and inevitably spilled over into lunch. The dining room, which used to be silent except the clanging of silverware on the plates, came to life.

The year was 1994 and the industry was just starting to think of the special needs of their dementia residents. In the quarter century since, I have been visiting care facilities around the country and seen fewer than a handful homes that provided adequate time, space, and tools to support the creativity and explorations of their residents.

We were fortunate that our particular "Alzheimer's" wing of the facility was an afterthought, so there had been no attempt to "decorate" and the furniture appeared to be hand-me-downs, not particularly attractive but very useful, as it turned out. The inexpensive and lightweight formica topped tables were easy to rearrange for our special projects.

At this point in time there were no planned activities offered by the facility, so our little group quickly grew to a dozen regulars, plus occasional onlookers. We worked together on individual and group art projects, we printed out lyrics and had sing-alongs; we found a few CDs in the game cabinet, popped them in the player, moved the tables out of the way and danced.

Most days, as soon as the tables were cleared after breakfast, we'd set up our work tables and spend the mornings socializing and creating. There were times when residents were so engrossed in their individual projects that they didn't want to stop for lunch, so we'd hold their plates until they were ready. Everyone blossomed when the pressure of time and tight schedules were lifted and they were free to take the time they needed and wanted to create.

Basic Needs

Good work spaces, tools, and materials are basic to our success with programs for elders, including those with serious dementia. We all need plenty of time to explore and create. Unfortunately, many of our care facilities offer only one or two one-hour sessions devoted to creativity. When asked for the reason for such tight limits, some facilitators have told me that they tried longer sessions a couple of times but their residents didn't really show any interest, so they went back to a single hour. I've observed the stress in our residents when they had limited time to work on something. Many would simply give up and just stay on the sidelines. Anyone who has explored creative projects of any kind will tell you that the time needed is unpredictable. I may need two hours for a project that you'd do in one. It all depends on our individual experiences, habits, and styles. - I need at least half an hour to prepare my workspace, and set up the supplies and tools that I'd need. Next, it takes me 15 to 30 minutes to decide on where to start on my design. That would leave me with 10 to 15 minutes to create my masterpiece — only graffiti artists may be able to accomplish that.

Other basic needs are the "right tools" and quality supplies. As you peruse the projects in this book, you'll find that it doesn't have to break the bank to do this. One example is painting. Trying to do a watercolor on copy paper would guarantee failure for even the most experienced artist. The paper is simply too flimsy. Please use watercolor paper — or if your budget won't allow for that expense, an inexpensive alternative is card or index stock.

Ruth Dennis, MA, Vista Living:
"Real art supplies are important. Elders are not children! Supplies that are created for children do not need to be used unless there are children present period, end of story. Supplies made for children may be degrading to adults and often insulting to children and are not that much cheaper.

We use the following in our Vista Homes: Acrylic paint, acrylic media including iridescent medium, gesso, watercolors in all forms, solid, liquid, and tube

depending on the project, colored and iridescent inks in liquid form, good brushes for all media in a wide range of sizes and shapes, good quality watercolor, drawing, pastel, colored tissue, handmade and collage papers, pre-folded quality card paper and envelopes, clay, good quality multipurpose glues, stretched canvas and Masonite board, pastels both oil and chalk, drawing pencils, graphite sticks, vine charcoal, colored pencils both regular and woodless, watercolor pencils, mixed markers including sharpies, fine and medium point drawing pads and journals for elders who will use them, mandala books larger size, gold and silver leaf and size for special projects and framing.

Elder art needs to be properly framed and displayed in the home, including doing special food and having an "opening" party for an elder completes a series or a group finishes a large project. If an elder makes a card for a loved one, it needs to be mailed. Elder creativity needs to be respected and celebrated."

Ruth's list of supplies and tools is my ultimate wishlist; however, my budgets hardly ever afforded me that luxury. As you peruse the different projects presented here, you'll come across alternatives to the tools or supplies mentioned by Ruth, dictated by budget constraints or sometimes, convenience. A couple of examples: tile painting has consistently been one of our most popular projects. Porcelaine, the paint we use, dries quickly and will solidify in the brushes, essentially making them impossible to clean and useless. Replacing brushes with Q-tips and using small paper plates for palates to hold and mix paints has solved that problem. At the end of the session, the Q-Tips and plates can be discarded.

Art can be messy! Many of our most popular projects will usually result in scraps that need to be swept up off the floor; wall-to-wall carpeting can make this tricky. Our paint or clay projects may result in spills, so both the tabletops and the flooring need to be able to withstand these. You won't need to set up an elaborate art studio, — although that would be lovely. However, you do need an area or a room with multipurpose tables with enough seating for your group plus a few extra chairs. You need storage cabinets or shelves and preferably a sink. When we first pulled together our programs, we were fortunate that the facility had decided to

put all their energy into redesigning the parts of the building that housed independent living residents. New paint and new carpeting throughout. Granite-topped tables replaced the obsolete furnishings which in turn were sent to our end of the building. Our luck! The indifference to our population worked to our advantage. The formica tables and old vinyl flooring in the common room were easy to clean. The old tables showed their age with wear and tear, but they were 30 inches squares, lightweight enough that we could easily push them together into one large work area.

Purpose

Everyone needs purpose! You, me, your 6-year-old, and your grandfather. — we all need purpose. It can be anything at all. For one person it may be sorting out the mail, for another it may be signing petitions or organizing flatware, and in the case of one of our residents, it was reading, although she never got past the first couple of pages of a book, because she'd forget and would start over again. She was happy as a clam and would carry her book everywhere.

For almost a week, I had been seeing one of our residents sitting by one of the large windows in the atrium. He stayed there all morning, holding a pot with a tiny plant in his lap. After several days of passing him, I finally stopped to talk to him. He explained to me that his apartment faced north, so he had to find a south-facing window for his little plant to get the sunlight it needed to grow. It was such a tender thing to do that I wanted to hug him in that moment; instead, we talked about water, sun, plants, and the nursery he used to own. He had Alzheimer's and his short-term memory was terrible, but when it came to his passion: plants, he was completely lucid. –I was a little late for a meeting that morning, but it was well worth it.

When I first meet with people living with dementia, I'll get them to talk about what brings them a sense of satisfaction and purpose. They'll usually talk about projects around the house or arts/crafts projects. However, as I said before, purpose can be *anything* — but this one time was a new one. I was meeting with Elisa and Carl when he was diagnosed with dementia. I asked Carl my usual question: "Is there something you enjoy doing at home by yourself?" His answer took me aback. "My taxes!" - Elisa sat behind him shaking her head and rolling her eyes. Later she said, "He can't do them anymore; he'll mess them all up." I recommended that she make copies of all the paperwork and give the originals to their accountant and the copies to Carl. That way, he could do his taxes to his heart's content.

On the other hand, many of our residents and friends discovered new skills and passions participating in our group projects. I believe it's because group projects take the pressure of the individual to "produce" something.

Process - Not Product!

The projects in this book were chosen because they work in their simplest or most complex versions and they work for people with a wide range of ability and experience. I focus on the *process*, not on the *product*.

When we use traditional art media, i.e., painting or drawing, I've found it's best to avoid realism. Most of us haven't created a painting or drawing since we were kids but we still have our ideas of what we consider "good art" and it's natural for us to strive to create something similar. The reality is that very, very few of us are skilled enough to accomplish this.

When we first start, I urge our groups to work simply with colors and shapes. I want everyone to understand that there is no right or wrong when it comes to art. The end results don't matter as long as it was a gratifying and fulfilling experience for everyone. Our sessions should be engaging and purposeful, but primarily fun.

A couple of tips:

#1. I suggest that you sit at the worktable and participate equally as much as possible, rather than walk around or stand behind someone like a teacher. Even if you're not participating in the art-making, the fact you're all at the same level makes a big difference.

#2. Refrain from asking "what is that supposed to be?" — or "that looks like . . . " - or "why don't you paint (something specific)?"

#3. The individual resident decides what he thinks of as an *activity*. He may want to fully participate with the group, continue work on his own project, or he may spend the time simply sorting stuff and never actually get around to *producing* anything. However he is just as engaged as anyone else. He has an activity with a clear purpose: to get all the paint bottles lined up perfectly — his demeanor makes it clear that this is a very satisfying experience for him. We just need to remember to compliment him as much as we compliment a resident who just finished a painting.

As an artist, I have my personal notion of how and what to do, but I try to leave them at the door, because ultimately, there's no *Right* or *Wrong* in any project. I never say, "What's that supposed to be?" or "That looks like (a whatever)" - I'll leave that up to the maker, while I comment only on colors or shapes etc — (only positive comments.)

I may have several residents working with the same basic supplies but I encourage individuals to use them as refrain from having everyone working on the same theme: i.e. Thanksgiving turkeys or Mother's Day cards. Everyone doing the same thing automatically creates competition and, because of our culture, this sets people up for failure. (Remember your art projects in elementary school? Wasn't there always someone who did a much better job than you?) We encourage everyone to give input and to engage in conversations.

It's impossible to cover all the projects that you might want to include in your program, so I'm sharing with you a few favorites of all my groups. At a glance some of these may seem complicated, but I've chosen them because they can be adapted to the different levels of your residents' ability. I take you through the step-by-step of how-to, hoping that you'll try them out and see that they are actually quite doable. I trust that they will inspire you to think out-of-the-box when you design your program. There's something here for everybody regardless of the cognitive ability of your participants. One thing you won't find in these pages is Bingo! I wrote this book to help you in setting up a program that's enjoyable for you while offering your residents inspirations and engaging them in something creative.

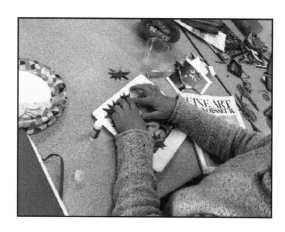

Fiddle Box

When you work with residents with dementia or Alzheimer's, you're likely to spend much of your day answering the same questions over and over again and doing your best to keep some people calm and others from sleeping the day away and pacing through the night. You need a quick fix. That's where your fiddle boxes come in. There's no question that *fiddle boxes* have become our most important projects and most effective power-tools. We keep a variety of them handy at all times and find them to be a good activity for folks who stay up nights. These boxes can be as complex or as simple as you want. They can be thematic (kitchen/cooking, fabrics, hardware parts) — like an activity center in a box. I suggest that you ask the staff to help put together these boxes. If they are involved, they are more likely to use them.

Tools and Materials:
- A container (shoeboxes work well, because they are just big enough to hold a bunch of stuff and still not be overwhelming).
- Stuff to be counted, organized, sorted, rearranged, admired, discussed, or simply touched.

How-to:
To create your Fiddle Box, take a stroll around the house and collect odds and ends in a shoebox. A quick treasure hunt around the house for interesting stuff resulted in the fiddle box pictured below.

Here are a few ideas that we came up with. By no means all the possibilities:

- Baking and cooking stuff: small wooden spoons, measuring cups, ladles, whisks
- Office stuff — small notepad, hole punch, erasers, pencils, paper clips
- Jewelry: long strands of beads in different colors, necklaces, pendants and clip-on earrings (no rings or pins)
- Baby things: pacifiers, baby clothes, bottles, rattles, small stuffed toys
- Art supplies: dried tubes of paint with their caps super glued in place, crayons, brushes
- PVC pipe connections and safe small tools
- Packets of seeds, a garden catalog and plastic gardening tools
- Clips from magazines
- Recipe file
- Playing cards
- Individual paint sample cards, (found on racks at a home improvement store)

and *post cards*, especially when they are personalized.

And of course you don't HAVE to use a shoebox or even a box. Below is a *fiddle-tray.*

And a lucky find at a flea market. It's made from cardboard and appears to be painstakingly made by hand. Found for a pittance at a flea market, it was already a treasure trove of buttons and sewing stuff. Over the years it has served us well as a fiddle box. We had to empty it of all the loose buttons (choking hazard). And fill it with all sorts of weird stuff.

An old makeup case with extra pockets in the lining;

Using Fiddle Boxes

Most of us will sort stuff.

Human beings apparently have a strong need to bring order to chaos and that's the secret to the success of fiddle boxes. Some years ago I had arrived early to a presentation I was to give to a group of managers and activity directors of care facilities. I had brought with me six different fiddle boxes that I was planning to address as part of my presentation. The room happened to hold six large round tables, so I set a box on each table to spare us from an interruption later. As people drifted into the room and seated themselves, it wasn't long before they were rummaging through the boxes, pulling things out, sorting them, and talking about them. – As I told the group later, most folks cannot help themselves. That's why fiddle boxes work.

When a resident is restless, pacing, or even agitated, you can solicit his help straightening out one of the fiddle boxes. It's important that you present it to him as a serious task that you need help with. At some point when you sense that he feels that he's finished, you'll want to thank him — even if he did nothing except simply look at it.

Once you've learned that a resident has interests in one particular area, you can create a fiddle box especially for him:

Willie had reached the advanced stage of Alzheimer's disease. He was wheelchair bound and his ability to speak was pretty much gone. Most of his remaining vocabulary was limited to colorful curses, which he would practice loudly, especially whenever everyone else was having a lot of fun. We tried to get him involved in our activities to no avail.

Since our space was limited we had to co-exist, which had become increasingly difficult with Willie's constant disruptions. None of the other fiddle boxes had worked. We contacted his family and learned that he used to own a thriving business supplying builders with custom and high-end windows and doors. We created a box for him with 20-30 pictures of windows and doors cut out of decorator

magazines. It was pretty easy to get him engaged by making a comment on a single picture. We would extract just one picture and admire it. Soon he would follow suit, pull out the pictures one by one and lay them out on the table, methodically sorting them by size, style , etc.

Elaine was a nurse — retired as far as the system was concerned. However she was nowhere ready to hang it up. Physically she was in great shape, but unfortunately her dementia had affected her mental functions and her mind was in a constant turmoil. She had a very hard time when she was moved into our Alzheimer's facility. We had very little to satisfy her need to be busy and engaged. Based on what we learned about her past, we filled her box with bandages, rubber gloves, cotton balls, tongue depressors, etc — you get the point. We also gave her black and red ballpoint pens, a clipboard with a chart and a name tag with her name and: *Assistant Nurse.* Our nurse at the time played right along and when Elaine was restless or anxious, she would solemnly ask Elaine to take the notes as they were doing rounds to check the vitals.

Alvina had her first morning at our facility. Apparently there had been no attempt to help her with a gentle transition. She was understandable very angry. Her loss of language (aphasia) only exasperated her agitation. Alvina was a large woman, so when she started swinging at the staff and other residents, we needed a distraction instantly. I grabbed the closest box at hand, which happened to be a box of several hundred crayons, old and new, all colors and at different stages of wear. Admittedly, I was as concerned as everyone else, so I took a deep breath hoping to hide my apprehension as I handed her the box and as calmly as possible said, "Hi Alvina, it's so good to meet you. – I hear that you're great at organizing stuff. I sure could use your help with this box. Would you mind helping me sort it out?" Alvina stopped abruptly, looked at me and then focused on the box and nodded with a half smile. I placed the box on a table in the dining room and pulled the chair out for her. She immediately started laying out the crayons. Two hours later it was lunchtime, but she was still at it and we didn't dare to interrupt her for fear that her agitation would return, so we rearranged the seating in the room. She continued happily until she had hundreds of crayons very neatly laid out by color, tone and length in a beautiful pattern.

Kathleen was easily overwhelmed by our group projects. We knew she had an affinity with sparkles and jewels and I happened to have a collection of inexpensive costume jewelry, including a number of necklaces and half a dozen long strands of "pearls" (bought by the foot from the hobby store). I created a special fiddle box for her. She dove right into the tangled mess and started sorting them out. It was the most engaged she had been in a long time. From then whenever she started to show agitation, we would hand her the box and ask her to help us sort it out. She would find a quiet corner and start making designs out of swirled strands. This kept her happily occupied daily for well over a year.

Fiddle Bags

Another lifesaver is the fiddle *bag.* I keep one in my handbag purse at all times, so it's always close at hand in case of emergencies, i.e., being stuck in a waiting room. Much as I try always to get an appointment where we can walk straight into the exam room and not have to wait, there are still times when the unforeseen happens and we find ourselves stuck with a long wait that's likely to stress my companion's patience. This little bag has kept many a resident happily occupied during our waiting room waits. The twenty-five 20 - 24in pieces of ribbon and lace are long enough that present somewhat of a challenge to someone rolling them up. On the other hand, the bag is small enough to carry in your handbag.

Puzzles

A family member had brought a puzzle for one of our residents. It was probably the very simplest one they could find. This puzzle was obviously meant for very young children, a kiddy-cartoon with 10 large individual pieces. It lay on the table untouched. The problem appeared to be two-fold: The image itself was insultingly juvenile and the pieces too complex, especially the tabs. I'm personally a big fan of puzzles, so I started experimenting. First I used cake-mix boxes and paint chips.

I include paint chips here because they could be considered "puzzles" with the big advantage of having endless "right" solutions. They make interesting patterns or mosaics. These are a great pastime for hungry people waiting for their meal. I always keep extras on hand, because they often end up in residents' rooms.

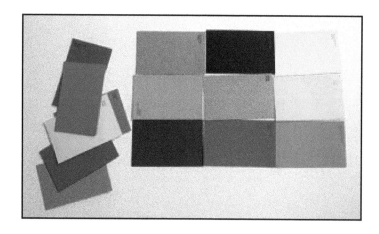

Tools and Materials:

Large image chosen by your residents. Wall calendars usually work particularly well for this project.

Utility knife or X-acto knife

Foam Core or corrugated cardboard

Select a picture. Paste it on to a piece of board with spray adhesive, ModPodge, or glue stick. (Spray adhesive works best, although it should be applied outdoors only by you and away from anyone else. It's also a very sticky substance, so be sure to lay your board on top of a wide spread of newspaper.)

How-to:

Cut into three to five sections with a utility knife or an X-acto blade — (either is dangerous and should only be handled in a controlled way).

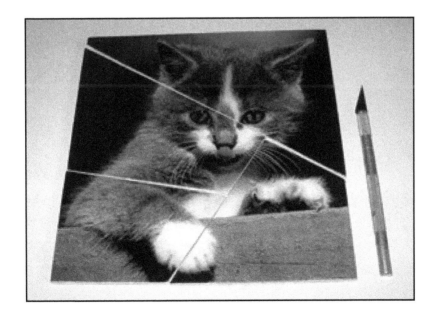

Collages

Collage, *assemblage* and *decoupage* are terms for an assortment or collection of pictures or other items arranged and assembled into one unit. You can *collage* with anything and on anything. If it's three-dimensional, it's called an *assemblage*. When you collage on wood objects, you'd use more durable glues and finishes and it's known as a *decoupage*.

Tools and Materials:
- Large board (mat board, foam-core or poster board)
- Glue sticks
- Scissors
- Magazines (i.e. art magazines, Smithsonian, and National Geographic)-
Our most positive reactions and results have come from using art magazines.

Optional:
- Color construction paper
- Glitter paint (clear liquid with glitter or foil stars)
- ModPodge. A combination of glue and glaze; works especially well if you want to layer tissue or rice paper into a collage.
- Clear high gloss polyurethane lacquer for finish, if you wish.

How-to:
Start with a poster board, mat board, foam-core or corrugated cardboard.

Optional: To make a no-fail collage, first lay down a background by covering the board with different colored construction paper or some other colored paper. That way the collage will look cohesive even with only a few additional images added on top. On the other hand you can continue to add pictures, gluing one on top of the other until you're satisfied. Our group collages often end up with many layers, as people find more images to add on top. Cut or tear images of your choice, arrange them on the board and when you're satisfied, paste them down with glue sticks.

Storytelling Collages

Any collection of images used for a collage can inspire a (sometimes weird) story, but you may want to deliberately create a story with your images. Notice the difference in these examples, using the identical images.

Straight edges can create walls or barriers between the elements. A uniformly colored background, in this case it's white, may be too prominent and create a bigger separation between the pictures.

Even if these images share a theme, each stands alone. The background becomes a virtual "frame" that isolates the images from each other. Below:

Below: Simply by overlapping the images we start to see the connection.

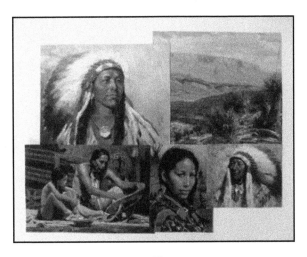

Finally, when the images are cut or torn to shape and overlapped, they flow into each other. This collage now tells as story.

When you're working with a group of people with cognition and memory problems, these collages can prompt wonderful interactions, sometimes they awaken old memories. That happened with this bucolic scene. Everyone chimed in with memories of picnics and outings with their families.

Individual Expressions

After weeks of working on the group projects, some people wanted to create their own. I'm fascinated by how people expressed themselves in their work.

On the right is the work of an architect who was also a Zen Buddhist. No matter which media she used, everything she created was geometric and structural.

Harold had only lingered on the perimeter of our group activities. His tremors were so extreme due to Parkinson's that he was unable to hold anything. One day he ventured into the middle of the circle and indicated that he wanted to participate.

A couple of residents took it upon themselves to slowly turning the pages of the art magazines for him to choose the images, which they then cut out for him. He pointed to how and where to place them. A slow process, but everyone was very pleased with the end result, especially Harold.

< A professional businesswoman who had never had the time during her career to explore her creative talents. She caught on very quickly and was soon producing work impressive enough that she was offered a show in an exhibition space. At the opening reception she kept asking what we were doing there and didn't recognize her own work in the unfamiliar setting.

Collage making is such a perfect medium for a mixed group, from those with mild dementia to people in the very advanced stages of the disorder. People may use their collages to express feelings, personal history, or simply explore colors and shapes in an abstract design, as seen below.

There are no rules that say that these collages have to conform to rectangles or squares or stay within the edges of the boards.

The piece below to the right is an assemblage of images simply pasted onto a page in a magazine. >

Triptych, 22" tall

This undertaking spanned a whole summer. In between working on other projects, people would add a picture of two, often pasting over an old one. Amazingly, everyone collaborated and nobody objected even when their last contribution was obscured by someone else's cutout. When everyone felt satisfied that the piece was complete, we added a few sprinkles of glitter and sprayed it with three coats of high-gloss lacquer. It's a glorious piece, I must say!

One day we'd run out of the boards we normally used for collages and painting. But we had paper plates we used to hold snacks. It occurred to us that these plates might be "naturals" for some of our projects. They have a built-in "frame" and still a large enough surface to work with. One additional bonus: they are sold in packs of ten at the dollar store.

The plates turned out to be a favorite with our groups. They were small enough that a person could finish a pretty impressive creation within an hour and the rims of these plates made a natural frame.

Painting

Most of us have not made art or painted since childhood, but even so we have very high expectations of ourselves and are easily frustrated and disappointed when our work doesn't live up to our visions. We know what we personally consider "good art," which for most of us means figurative or realistic. We also have a tendency is to get stuck in minute details as we strive for "realistic" images (houses, trees, cats, dogs or flowers).

I've found it really helps novices feel accomplished if I can get them away from realism and get them to try their hands at abstractions instead. If I meet with reluctance, I may ask the group to simply test the materials, the boards and brushes, by focusing on colors and shapes. At other times, we've started with the rule: *"It can't look like anything."* When it can't look like anything, it frees people up to explore shapes and colors. In other words, we'll start with abstractions.

> If you look at the works a few art superstars of the last half-century, you can see that they have come very far from traditional landscapes, portraits , etc. I share this with you to help you get away from the idea that a painting has to *look like something.*

Tools and Materials:
Watercolor paper or heavy board (example: mat board)
1-inch foam brushes
Poster paints

About your tools:
You can use watercolor paper or ask your local framing shops if you may have the leftovers from their mat-cutting. When framers cut a mat, the center is usually considered waste. I use these leftovers and scraps, because mat board is substantial enough to withstand being wet.

Brushes - 1-inch foam brushes are easy to clean and they're wide enough that it's almost impossible to make skinny lines. You can use Q-Tips for small details.

Paints - I've experimented with a variety of paints and consistently my best results for larger paintings and abstracts have been with inexpensive tempera or poster paints (watercolors). Acrylic paints dry quickly and once they're set, they are waterproof and thus work really well on fabric, although they have a tendency to make the fabric stiff. However, they don't work too well as watercolor.

About colors (technical info): All colors are derived from the three primary colors: red, blue, and yellow. We use white and black to achieve different tints and shades. In addition to the primaries, we also use the three secondary colors: orange, green and purple. I ask each person to select only three of those colors, because using any more than three easily turns the image to "mud."

How-to:

Cover your table with a plastic tablecloth.

Wet down the board by passing it under the faucet.

Shake off excess water.

(Keep a clean sponge handy to rewet the board.)

Select three colors.

Wet the foam brush, squeeze some of the water out of it. It will take some practice to know just how much water you want to retain in your brush. As you apply the paint to the wet board, it will flow or feather and make interesting forms on its own. When you add a small glob of a second color, the two may swirl around each other or they may blend. The motto for this project is: Less is more. The trickiest part is knowing when to stop.

The works shown here were mostly created by people who had not engaged in art making since they were kids. The secret to this kind of success is to give folks the option to spend as much time as they need on the projects of their choice, even inviting them to work daily and forego other activities.

The work on the right took an enormous effort by a person with debilitating Parkinson's. He had been sitting off to the side, watching others work for a couple of weeks until one day he finally decided to join in. He worked on this for most of an hour, dropping his brush often, but sticking with it until he indicated that it was finished.

We framed it and hung it prominently in the dining room, just opposite his chair.

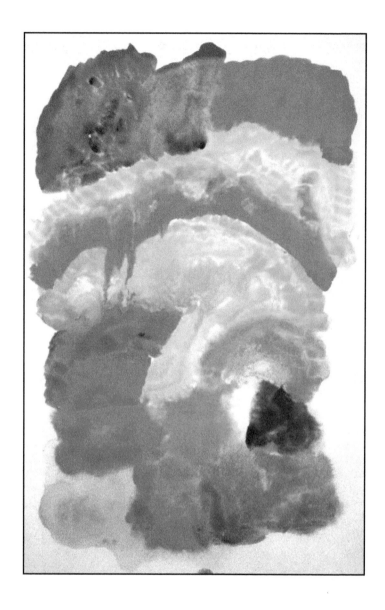

By the time Ellie painted this piece she had become very proficient in her techniques. When she'd finished, she apologized to me. I asked her why, to which she replied, *"I know my painting is not supposed to look like anything, –but this is Strawberry Ice Cream."*

I couldn't disagree, so I laughed and said, *"Sure enough! It's such a happy piece, let's hang it up. It will make everyone feel good."*

All the paintings shown on the previous pages were done with the three primary colors: red, white, and blue. Some of our participants started experimenting with other color mixes, still using no more than three a time. The "amoeba" (my title for the piece) above was created with the secondary colors:

Orange, Purple and Green.

Left: This person gave up on her painting when she noticed the special effects of the water based paints on a paper towel. This inspired others in the group to look at different possibilities. We'd been using paper plates as "palettes" to hold the paints when some folks in the group started painting these "palettes" themselves.

Paper Plate Painting

One thing led to another. The round plates had their day until we found square paper plates with rims that could function as "frames" - These paper plates are a good size for a project and yet, small enough that you can complete a work in one sitting.

We had to change our paints, however. Because of the coating on the square plates, poster paints tended to bead off and didn't want to stick the slick surface. Once we switched to acrylic paints we no longer had those problems.

On the left is a portrait of "Cochiti", an African Grey parrot who's been a regular guest at our Alzheimer's Café for several years.

Group Projects

Group Collage

I'm a big fan of activities that promote a sense of community and help our residents to bond with each other while sharing interesting projects. They can be as simple as a conversation over a meal or an impromptu "celebration" — as an example: A "Happy Monday" party, which can be as simple as a declaring that this is a special day and adding a table centerpiece — created by residents.

A large group collage gives you the most immediate fail-safe results and is perfect as a first project for a new group. No matter how many or how few cutouts each individual contributes, everyone has *ownership* of the project. Eight residents worked together over a 2-day period to create this Kachina collage.

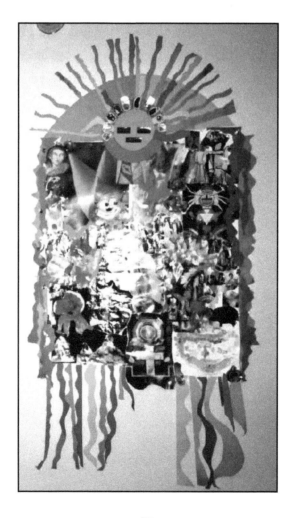

The Kachina collage started with a 20" x 30" poster board. With the fringes added it grew to 25 x 65 inches. Everyone enjoyed this project so much, that we ended up with a whole series of *Kachina* collages. We took down the commercial prints in the hallway and proudly displayed our *Kachinas* in their place. (A kachina represents a deified ancestral spirit in the mythology of Pueblo Indians.)

The story of the fringes and borders:

I had set a brand new package of different colored construction paper behind me. I was busy interacting with the rest of the group while we were setting up, so with the confusion and noise I didn't notice Lulu behind me, scissors in hand, happily cutting away at the construction paper. We found ourselves with all these long slivers with no place to go. After some brainstorming someone suggested that they would be perfect for fringes and borders. Lulu was only too delighted to keep

cutting fringes and borders. The fringes and borders were so popular that we invested in a set of fancy pinking shears.

Mural Projects

Another great group project is mural painting. In this case, we were at the New Mexico History Museum. Several people took turns adding their personal expressions to our piece. We call this a "mural" because of its size, in this case it's a 4 x 4 foot masonite, primed for paint. We use poster paint and an assortment of tools for application, from twigs, rags, sponges, and regular brushes with dowels attached to extend the handles.

< Our finished masterpiece. The truth is these projects can go on forever and it was up to the dozen makers to decide when the work was "finished."

It's hard to tell in this small image that this work includes tissue paper, rice paper, and colored construction paper.

Our Mural Projects with Elders

By Ruth Dennis, Vista Living Senior Care, NM

A small group of elders and I applying gesso to a large 4' by 4' or 4' by 8' Masonite board on the rough side with gesso. The following day we discuss what to do as a group (members can change), what images we want to add. The group picks a theme around a word, song, thought or event. Then we experiment. Sometimes we follow the theme sometimes it changes in the middle.

The group starts to draw; staff and elders working together, adding some paint at the same time. Work can be done either on tables or upright depending on the space and weather. Paper or plastic plates are used as palettes with colors of elder choosing. Some colors are put in cups separately. Everyone trades cups, brushes and seats, painting gets rotated so different parts can be worked on. The facilitator washes brushes, makes sure everyone has supplies, and that no one eats the paint — and asks questions. Better to have 2 facilitators. Do we need blue here? Does this need another flower, moon, spiral or what happens to come up? What do you think of this? Hand over hand can be used to support an elder with tremors.

If someone gets stuck, make a mark and have them add to it or respond to it. Elders leave the group and come back. Different elders join at different times. This is not a 45-minute process, I block out 2-3 hours and several sessions. The facilitators will go home tired. Our two most recent murals were done in Santa Fe at **Vista Hermosa** and **Sierra Vista**. Our home in Las Cruces, the Arbors, has a fully functioning open art studio.

Different groups will work at different speeds and have very different approaches. The group at **Vista Hermosa** is methodical and works slowly, meditative in their approach. They chose subtle colors, used many iridescent paints and ink, and created a structured mural. This group loves smaller more precise brushes and stayed with a theme in a dedicated, almost obsessive way. They created an image of "Rebirth" with 2 large old trees, a growing vine and butterfly images. They added and painted out hearts, put in halos and flowers in the roots of the tree with one of our caregivers. "Rebirth" is a 4' by 8' mural, which is framed and hanging in the elders' dining room.

As a contrast, the **Sierra Vista** group is full of energy, preferring larger softer brushes and bright colors and a complex color scheme, combined with bold images. They worked very rapidly. Two elders were very detailed while others made big bold marks. One lady moved around the whole painting adding marks throughout. They chose a Sun and Moon theme with spirals, waves, vines, several tulips, and a layered heart. This painting is 4ft by 4ft. They are still considering a title.

Both groups found the process of using gold and silver leaf interesting and used this technique to highlight areas of the paintings. Each group decided when their painting was finished by vote. These elders work in collaboration despite confusion, fatigue, struggles with verbal skills and physical challenges. They do communicate, have great ideas, and express clear opinions. They are not limited to coloring books and pre-made craft kits. They are artists. Elders have as much or as little potential as the people around them allow them to have. It's our job to have faith in our elders and their vision.

Sticks and Stones

One of our friends brought this great project to us. I highly recommend that you try it. You'll need acrylic paints, river rocks and stripped twigs or small branches. This is one time when Q-Tips are not sturdy enough to hold up to thick paint and rough, uneven surfaces. Instead, we use stiff nylon paint brushes. You'll want to keep the paint viscose (thick and undiluted) to give you good coverage.

One drawback to acrylic paints is that they dry very quickly, so you'll want to keep brushes moist. If your brushes that still have paint residue, soak them in alcohol. It may work.

Above: Cochiti is a regular participant in the Alzheimer's Café for several years. Her favorite activity is visiting with people and munching on almonds.

We had a lively conversation about how to take these projects further. Everyone agreed that the painted rocks are perfect as they are, sitting on a coffee table or used as a paper weight.

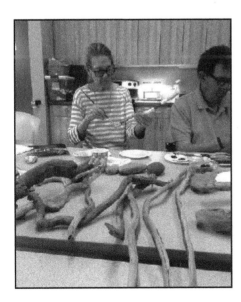

The sticks had been stripped of their bark and we used the acrylic paints for these as well. Later some of these painted sticks were incorporated into hangings.

Textures

I'd purchased the smallest tub of sparkling I could find to repair a small hole in the plaster. After the repair was done, there was at least 98% of the spackling still left in tub. Spackling dries up quickly and when it does, it's rock hard. Not having any other purpose for the remainder in the tub, I decided to experiment with the leftovers. I used a dinner knife to spread it on a board in interesting pattern. After it dried, I painted it with diluted poster paint.

Painted Tiles
Or porcelain or glass objects

This project relies on a specific product, a French acrylic paint specifically designed for china, glass, or ceramics. We've tested other similar products, but this particular brand is so far superior that it's worth the extra expense. The good news is that it goes a very long way if you follow our methods.

Tools and Materials:
• Porcelain or ceramic tiles, plates or cups, or glassware
• *Porcelaine®* brand paint
• Q-Tips
• Denatured alcohol
• Small disposable plate
• Plastic cup
• Eyedropper or makeup sponge (optional)

How-to:
Cover your table with a plastic tablecloth.

Choose 2-3 colors

Scoop a small amount (pea-sized) of *Porcelaine®* onto the plate.

Pour a small amount of alcohol into the plastic cup. Clean the tile, plate, or cup with alcohol. Wet your Q-Tip with alcohol. Apply a dab of color into a tiny "puddle" of alcohol on the tile. If it doesn't start to flow, sprinkle a little more alcohol over it with an eye dropper. You can also use a make-up sponge or a small foam brush; either will allow you to squeeze out a small amount of alcohol. If you decide that you don't want the paint to flow, you might still want to use Q-Tips that can be discarded at the end of the session.

Porcelaine® goes a very long way, however, so it's important to keep the bottles capped. The primary reason for this is that the paint dries very quickly. You also want to keep the colors pure; allowing people to dip their Q-Tips into the bottle will sooner or later lead to colors getting contaminated. Instead use one Q-tip per color and give people extra Q-tips to use for mixing.

Above: I was impressed with Mark's patience. He used to be a builder and thus was no stranger to a carpenter's tools, but handling a Q-Tip was a new experience for him — and it wasn't easy. His tile on the left.

As with any other painting project, people are encouraged to stick to no more than three colors. On the right: Ruby used the same colors as Mark:

The tiles on this and the next page were all created with the same three primary colors: Red, blue, and yellow.

Group project: Tile top table

For several months the tile project was by far our most popular activity. Consequently we soon had stacks and stacks of painted tiles. It hadn't taken long for everyone to master the technique, so we had a lot of beautiful designs. What to do with them? After much brainstorming, we decided on covering a tabletop with our favorites.

After all individual residents had chosen their top three favorites from their own stack of tiles, we laid them all out and as a group they selected the tiles for the table. Miraculously everyone ended up having at least one of their tiles included on the table. Residents set and grouted the tile and to finish, painted the frame.

Fabric Painting

Three examples of fabric painting: one very simple and low cost, one with minimum investment — and finally permanent dyes, a project that requires investment in special dyes, but still very doable.

About fabric choices: natural fibers work best with all of these methods. The dyes only take on the cotton, rayon, or silk so the higher the percentage of these fibers in a poly blend the more intense the color.

Sharpie Painting

Tools and Materials:

• Sharpie permanent markers
• Cotton tee shirt or other white
 Or light cotton garment.
• Denatured alcohol

How-to:

Lay your ironed cotton fabric on a board covered with plastic. If you're painting a tee shirt, cover a board with plastic (grocery bags work great) and slip inside the shirt. Draw your design with Sharpie pens.

When you're satisfied with your design, dabble alcohol over the painted surface until it's all wet. The colors will start to bleed and mix. Once your fabric is dry, you can go back and draw some more and once again sprinkle it with alcohol.

Sharpie "Tie-Dye"

Tools and Materials:
- Sharpie permanent markers
- Cotton Tee Shirt or other white
 Or light cotton garment.
- Denatured alcohol
- Plastic cups or glass goblets
- Rubber bands or thick cotton string

How-to: Stretch your fabric or tee shirt over a cup, secure with rubber band or cotton string. Scribble on the stretched surface with your Sharpie pens.

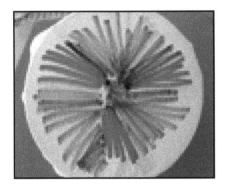

Sprinkle the fabric with alcohol* and keep it wet so the colors run and bleed into each other.

(Water does not work)

Fabric Paints

Josephine was in the very advanced stages of Alzheimer's, unable to perform the simplest ADLs (activities of daily living) and unable to communicate except with grunts and single curse here and there, but she loved painting tiles. She had painted tiles daily for weeks and now mastered her techniques. One day I had miscalculated our needs and we ran out of tiles. Josephine was visibly upset. Knowing that she was likely to become agitated, I rummaged through our storage for a substitute until I could replenish our supplies the next day. All I could find were fabric scraps. Following the routine she used on her tiles, she immediately doused the fabric with alcohol and dipped her Q-Tip in the fabric paints.

Tools:

- Acrylics or fabric paints, some 3D if you wish
- Denatured alcohol
- Q-Tips
- White or light cotton fabric

How-to:

Cover your table with plastic. Soak your fabric in alcohol. It's important that the fabric stays moist or wet. Alcohol evaporates very quickly, so if you're working with a larger piece of fabric, soak only the areas you're working on, one at a time. Keep a small cup of alcohol handy to sprinkle on your fabric if it starts to dry. Choose three or four colors. You only need a small quantity at a time. If you need to thin the paint, use alcohol.

As much as possible, use Q-Tips in place of brushes. They are surprisingly durable and you simply throw them away after use. If you need to use brushes for lettering and other fine details, be sure to keep them moist and soak them in alcohol to clean them.

Josephine's fabric paintings.

To achieve effects as shown here, the fabric needs to be kept wet with alcohol as long as you're still working on it.

Below: After this piece was dry, the shapes were outlined with dimensional fabric paints, squeezed straight out of the bottles.

Inko Dyes

Inko dyes are great for natural fibers. Light-sensitive dyes they are "set" by exposure to sunlight or heat. You'll want to work indoors before taking it outside to develop in the sunlight.

Advantages: Once they're "set", these dyes are washable; they are "vat dyes," which means they dye the individual fibers, rather than coat them, as do acrylic fabric paints. The Inko dyes are great for garments, napkins, pillow cases and such.

Tools:
• **Inko** dyes - Shop around for the best deal.
> You can do almost anything with the three primary colors: Yellow, red and blue. If you wish, add extender and resist
> • Fabric: Cotton, Viscose Rayon, Linen and Raw Silk (natural fibers)

How-to:
Wash brand-new fabric in plain water to remove factory finish, which acts as a barrier. To make your design you have many options: You can use a regular brush to paint designs on your fabric. You can use the method shown below or you can use stencils. If you want to dilute or lighten your colors, you'll need to add extender.

A simple project using only one color: *Blue,* which appears as yellowish tinted water as long as it's liquid, turns *lavender* as it dries (indoors) and then *bright blue* after sun-exposure.

Working indoors away from sunlight, paint a swatch of cotton with blue dye, which will appear very pale yellow.

Within minutes the fabric will turn to lavender as it dries. Lay objects on the fabric and then bring it outside in the sunlight to "develop." Your objects will block the light. You can use lace, paper cutouts, letters, or live plants, as shown here.

Below. Quilt by the author, 1992, Inko dyes on cotton. 96" x 96"

Display with Dignity

One December day I stepped into the elevator at a local assisted-living facility. The walls were covered with white paper plates drooping under the weight of a profusion of cotton balls. It took me a few moments to realize that these sad objects were supposed to represent snowmen. *The products of the activities program.* Looking at the pathetic exhibit I was saddened and once again I asked myself: Why? Why do we think it's okay to expect our elders to be happy with activities that our second graders would probably consider childish and demeaning?

The residents of this assisted living facility may have problems with their memory but they're not stupid. If I had been one of the residents who had worked on this activity, I would have been offended.

It's up to us to find a way to display people's work to the best advantage. On the left, we attached these colorful pins to an apron with a hand painted appliquéd top.

I collect all sorts of frames at garage sales and specials at hobby stores. Depending on their condition, we may have to spray paint them back to life.

< This minimal design takes on an importance when framed properly.

Below: Our "gallery"

Clay

I love working in clay, but it can be messy, so you need a work area that is easy to maintain and clean. Ideally, you have a studio or a dedicated room with work-tables easy to clean up for your projects that require water.

I have used modeling clay (plasticine) but I prefer to low-fire clay, for a couple of reasons. Ideally, you'll have access to a kiln, but if not, once the clay pieces have dried dries, you can paint it, it will last forever.

These pictures are from one of the rare occasions when we had a particular project. In this case, it was led by a docent from the history museum who gave an informal presentation on pueblo pottery. On the right, the results from a more typical clay session.

Other Project Ideas

Pony beads strung on elastic >

< Inspired by Balinese hangings seen on a field trip.

To make these **"Birds":** use a square piece of fabric folded diagonally, stitched up except for a one inch "stuffing hole". Then turn and stuff with polyfill. The "head" and "tail" will turn up slightly once it's stuffed tightly. You can insert the "tail" into the stuffing hole and stitch everything in place. Sew and stuff wings and decorate as you wish. Sequins "eyes" as well as ribbons and laces are glued onto the bodies.

Right: Most hobby shops carry these wood shapes. *Pin-backs* are superglued onto the backs.

Singing and Music

Ethel's daughter Carol called me excitedly: "I can't believe it – Mother sang all the way to the doctor's office and back!" The daughter continued, "I don't know when and where she learned all of those songs. There was no music in the house when I grew up. Music was not allowed when I was a child, no radio, no record player, no dancing and no singing."

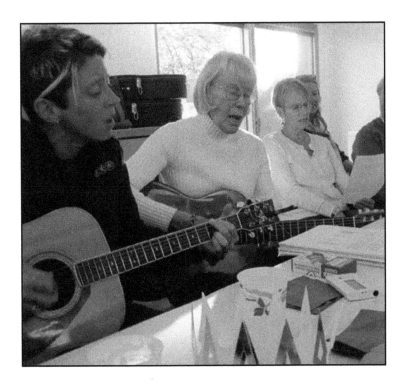

I had never known that side of Ethel. By the time I met her, she was already in the mid-stage of Alzheimer's. Her speech was halting and her thoughts definitely fractured, but she loved to sing. Now, two or three years later, she could no longer hold up a conversation, but she still sang. She sang in the shower; she sang on our walks; she hummed to herself while working on projects in our arts and crafts sessions. Ethel sang to me, to the cat, to the flowers in the garden, and to other residents. She was one of the kindest and most generous of our residents, always ready to cheer others up.

As soon as she started to sing, the aphasia* was gone. The lyrics flowed effort-lessly and she hardly ever missed a word. This is the same woman who couldn't remember from five minutes ago and often didn't recognize her own children. (aphasia* is loss of the ability to form words or sentences).

Ethel's repertoire seemed endless. Whereas I needed my songbooks, she had hun-dreds of songs memorized. —I dreaded to think of what must have been going on in her life for her to have deprived her children of music in their home. Whatever it was, it had completely vanished now that she was in the later stages of Alzheimer's, — one of the few the blessings of this dreaded disorder.

One day when Ethel and I were alone in the garden, I decided to try a little exper-iment. I started singing one of her favorite songs. Of course as expected, she chimed in after the first phrase, articulating each syllables. Then I suggested that we could make up a song of our own. I sang her a question and she sang an an-swer back to me. She would not have been able to answer me in a normal voice, but somehow singing brought out her voice.

Norma liked to sing. Digging through the supply closet at her facility I found a stack of "songbooks" — about ten single sheets stapled together, each sheet seem-ingly copied from a different source, the texts all different fonts and sizes. This was obviously confusing to most of the residents, but they followed along by memory. It didn't take long before the group wanted to add their own favorites. At first this led to a lot of confusion, but once we decided to get "serious" about it, we set up a sys-tem that worked really well and also brought a lot of fun and laughter.

I asked everyone to name some favorite songs or singers. Once we had a short list, I'd print out a few lyrics and we'd sing a cappella from memory. We'd start with full confidence that we all knew the melody but with many of the songs we could only get through the first few lines of an old standard before we were lost and singing in different keys. This is when we got our best laughs. We sounded like Siamese cats in heat: AWFUL!

These sessions helped to solidify the group. We were all in this experiment together, all equally bad, and all able to let go of any pretensions we might have had.

Our songbook creation projects last an average of six months and eventually we end up with a collection with a little something for everybody. The songs range from old classics to contemporary selections. Our books include standards by Elvis Presley, Frank Sinatra, Patti Page and the Andrews Sisters. We now have four books of about 25 pages each in folders with fasteners.

Our sing-alongs are almost ritualistic. I hand a book to each member of the group with short positive personal remark and at the end of the session, they all help me collect them again. It's important for everyone to have his or her own book, even if the books are never opened or held upside down. Once in a while a resident refuses to give the book back. But of course we've learned not to argue or insist with her and instead wait until she's distracted before retrieving it.

Melinda and I developed a ritual that we practiced before every sing-along. I would greet her with: "Melinda, please come join our sing-along. We really need your voice." - Without fail, Melinda would say: "You don't want me, I sound like a frog." To which I would respond, "Hey, every singing group needs at least one frog." She would laugh and later sing with gusto, albeit off key (or as we call it: *creative harmony*). This scenario was repeated at every session for the six-plus years that she participated in our sing-alongs.

Music and Memory Project. One of the most exciting recent innovations in eldercare is the *Music and Memory Project*. Thousands of elders in nursing homes are given iPods with their own favorite music. It's amazing to watch as they go from being locked into their own silent worlds to being completely connected and back to life as soon as they put on the headphones. (Look up "YouTube, Henry hears music") Music is a powerful way bring up memories.

A variation of "Music and Memory" is a group activity where everyone is either listening to CDs or singing songs from their youth, especially their high school years. To get started, I'll ask what a particular popular song makes them think of.

I usually use standards like "Blue Suede Shoes" or "Up, Up, and Away." These exercises can lead to lively group reminiscences.

Apparently, the areas of the brain that store music memory are often unscathed and unaffected by Alzheimer's. The belief is that music is the first impression that we perceive at birth and the very last that we sense before death. As a matter of fact, music is a lovely tool to help people through the last phases of the dying process.

Music has always been an integral part of my programs. The selections for our singalongs came about through collective brainstorming. As much as possible, we'd get suggestions from all our residents. Their choices could be song titles, genres, or specific artists. As you may imagine, our songbooks tend to be eclectic.

I also keep a collection of CDs on hand. Privately, I stream my own music digitally in iTunes or on YouTube but it's been important to have the CDs in their cases so people can handle them, look at them, talk about them, and discuss our music selections.

We try our best to get a list of favorites from families of each of our residents. I use them to help a person get out of a sense of isolation, a funk, or on the opposite side: to celebrate a big event like a birthday or simply a beautiful sunrise.

By the way: apparently the same brain centers that hold our music memories also hold our profanity memories. Oh, Dear! Your residents may resort to profanity because of frustration, boredom, or trouble communicating. When this happens, please keep in mind that this may be a behavioral expression. It's difficult to refrain from the gut reactions that most of us have had since childhood. Our first task is to identify the source of frustration and respond to that.

Shall We Dance?

Over nearly a quarter of a century, The Albert Einstein College of Medicine in New York City conducted a study of seniors, 75 and older, funded by the National Institute on Aging, and published in the New England Journal of Medicine.

The study measured the effectiveness of various activities traditionally thought to be beneficial for people with dementia to slow the progression and improve their acuity, i.e., crossword and other puzzles, reading and writing; physical exercise, including dancing.

The rule of thumb has been that anything good for the heart is good for the brain, with physical exercise being particularly important. Of course we should not stop exercising, but this study was focused on cognition as well and to everyone's surprise, frequent dancing outscored all the other activities.

These are some of the surprising results. Percentage of effectiveness in reducing the risk of dementia:

Reading - 35%,

Swimming and Bicycling - 0%

Doing crossword puzzles frequently - 47%

Playing golf - 0%

Dancing frequently - 76%.

Ballroom dancing in particular has several elements important to mental health:

Partnering, Socialization, Physical contact, Coordinating movements, Moving to beloved familiar music, and the feeling of well being that comes from the increase of dopamine in the brain.

My dad loved to dance. He danced ten days before his death at 96 1/2. The last twenty years of his life he had one dance routine, a hybrid of Danish folk dances and traditional waltz, which he somehow made work with any kind of music, from polkas to the Beatles.

Improv and Movement

We routinely start our days with a very short singalong and movement of some sort, from chair exercises known as "sittercises" to improvisational dancing.

Patty loved to dance. Before she developed balance problems, she'd often do small skipping steps down the hallway as she hummed to herself. A small stroke affected her balance to the point that she had to rely on her walker. Walkers and dancing don't really work, so we made up dance moves she could do while seated. Not wanting her to feel singled out, several of us would join her, seated in our chairs in a circle and "dance" with our arms and upper-bodies to Madame Butterfly and other classical favorites of hers.

There was something magical about coordinating our movements in silence. I had known Patty for several years by this time. She had always been one of my most enthusiastic participants. And yet, as we faced each other "dancing" in our chairs, Patty led our movements in silence, I felt intensely close to her.

Similar to our silent dancing is a popular improv game known as "the Mirror" — when it's played by two people, they'll stand or sit facing each other. The idea is very simple: One person makes a move and the partner "mirrors" the move. It also plays well with a group. We've used variations of this game with our residents. When adapted to a group, it becomes an excellent bonding exercise. — And it's simply fun.

I recommend using this and other improvisational games as part of staff training. Improv helps us relate better to each other and will often give us the best laughs in a long time. Any game that's similar to "The Mirror" will help to fine tune our ability to read body language, a skill that's particularly important when we're working with people in the late stages of dementia.

Celebrations

It takes so little to make each day special. You and I are key to everyone's enjoyment through our attitude and approaches. If we so declare, a simple meal can become a celebration. Try a quick online search into weird holidays or make up your own. Use your own list to inspire activities.

Examples:

January 3	Fruitcake Toss Day
January 21	National Whistling Day
February 7	Wave at Your Neighbor Day
February 11	Feed the Birds Day
February 24	National Chocolate Chip Day
February 26	Tell a Story Day
March 14	Learn about Elephants Day
April 17	Wriggle your Fingers Day
May 12	Write a Limerick Day
May 21	Wear Red Day
June 8	Best Friends Day
July 7	Butterscotch Pudding Day
July 15	Goat Appreciation Day
August 6	Bad Poetry Day
August 16	Tell a Joke Day
September 1	Make up Your New Middle Name
September 8	Banana Split Day
October 2	Tandem Bike Day
October 9	Cottage Cheese Day
October 14	National Apple Pie Day
October 27	Make up a Rhyme Day
November 7	Hug Holiday
November 9	Watch a Bad Movie Day
December 2	National Chocolate Covered Anything Day

Outdoors

When we've been fortunate enough to have access to the outdoors and the weather cooperates with us, we'll try to do as much as possible outdoors. On a particularly nice morning we move our projects outside. We might play lawn bowling or simply lounge in the sun (don't forget the sunscreen). At one point we'd gotten our hands on a croquet set but since none of us had ever played croquet, we made up our own game rules, which led to a lot of goofy laughs.

A sing-along feels really good in fresh air. At times the neighbors on the floors above us would join in the singing from their balconies. Of course, we also enjoy "normal" outdoor activities, like walking, gardening and barbecuing.

Flower Boxes

< On left: A simple flower box.

We use white wood or pine, a single 1" x 6" board @ 6 Ft: start by cutting the ends: 2 pieces @ 4 3/4" long. Cut the rest into three equal pieces (just under 21 in. each) — for the sides and bottom.

I prepare the boards at home by drilling holes for the screws (as shown on drawing). Then our group assembles the box with wood screws and finishes it off with drawer pulls for handles at each end and wood stain. Of course, you can take it a step further and paint fancy designs or cover it with a mosaic of small tiles.

Indoors you can set small flower pots in saucers inside the box. Outside, you can plant into it directly by covering the bottom with a layer of small rocks or pottery shards, then add potting soil and fill with colorful annuals. Just be aware that when you water the flowers, some water will leak out.

A raised planter box makes gardening much easier for folks, especially those in wheelchairs and those who have problems bending and squatting.

We were fortunate to have access to a sizable outdoor area, a large lawn and a patio with tables and chairs. When the weather was good, we'd take much of our activity outdoors. We'd built three simple flower boxes; organized several field-trips to the local nursery, first for the garden soil and then for plants.

We bought a bunch of zinnias, petunias, and pansies. They were easy to plant and care for. Our garden club kept them they looking beautiful. I would have liked for us to have raised our own salad greens, but our facility wouldn't allow us to use our own greens for salads. I hope you have better luck.

Outings

I realized early on that the simplest outings were often the most pleasurable, a random drive through the neighborhood. We realized early on the importance of keeping things simple. We choose only one destination for each trip. Over the years we've developed quite a list of favorite destinations for our outings: picnic tables along the river, a rose garden, a sculpture garden, the garden of an old inn that features a duck pond. I've developed relationships with several art galleries whose directors are aware of the special needs of our group. Exposure to both traditional and contemporary art and sculpture has en-

ergized our creative processes. When we've seen something particularly appealing, we'll try our own version as soon as we get home.

Right: Several of stately old cottonwoods along the Santa Fe River had died during a bark beetle infestation. Rather than uproot them, the city cut them down to 6 - 7 foot stumps and then invited a local sculptor to perform his chainsaw magic.

These are a few of our favorite destinations in Santa Fe:

 Sculpture Gardens

 Glassblower Studio

 Rose Garden and Botanical Garden

 Historic Old Inn with a duck pond

 Picnic along the river

 Museums (Folk Art and History in particular)

 Libraries

 Santa Fe Plaza

 A lunch place where they named a sandwich after us.

If you're not already doing so, I encourage you to explore your own community and when a gallery, shop, or café feels right to you for your groups, talk to the staff and give them the heads-up on possible scenarios that may come up for your group. I'll bet you that most of the people you talk to will be glad to work with you. I never had anyone even flinch. Everyone welcomed us and treated us the same as anyone else.

A very popular local event "The Fiesta de Santa Fe and the burning of Zozobra," signals the end of the summer season. Zozobra is a giant paper "puppet" created just for this one night event that draws thousands of spectators. This original *burning man* was first created in 1928 by local Santa Fe artists.

Tradition has it that you write your woes on a slip of paper that's then stuffed into Zozobra's belly and thus burned up when he's set aflame with great ceremony, giving you a new fresh start. His nickname is "Old Man Gloom" so the burning is good riddance to gloom.

This late evening event is too late in the day for my groups. The ceremony doesn't start until after dark. A very large percentage of the local population will crowd into the park at sunset, so many that it can be overwhelming. Instead we'd go to the park to watch the crews prepare the 40 Ft puppet for his impending demise the following evening at the Fiesta.

Santa Fe is named for St. Francis, patron of animals. I'd try to get us to the annual "pet parade" another very popular event.

Your city will have your own a popular community celebration. Have fun!

Another of our recurring adventures were *The Great Mailbox Expeditions.* Interesting and individual mailboxes are slowly being replaced by the large community units, which are boring and impersonal. We devoted many of our random drives to searches for unique mailboxes.

Above: This mailbox collection was found in the art district on Canyon Rd.

Below: All the mailboxes for the entire village of Galisteo are lined up in two very long rows, about fifty per row. We couldn't fit them in one picture, so this is a composite of five separate shots.

Another favorite annual destination is The Shidoni foundry and sculpture garden.

Eight acres of amazing creations from traditional cast bronzes to one-of-a-kind expressionist abstracts. On this day we were very early and we decided to take advantage of having the park to ourselves and get goofy.

Expressive Arts

by Lisl Foss, psychotherapist, Grahamstown, Eastern Cape, South Africa

A card for Annie.

One of the things I love most about relating to people who live with dementia is that it requires me to be fully in the present moment. I have found that if I tune into, trust and validate the emotion that someone appears to be experiencing — without question or judgement — it is possible to achieve a state of connection which is mutually enriching and rewarding, and can transport both parties to a place of great fulfillment. I became aware that this type of present focused interaction could be further amplified through the use of expressive arts when I was involved in facilitating arts and crafts activities with residents in a memory care neighbourhood.

During one of the sessions, the task at hand involved making a greeting card for someone special, using coloured cardboard, stickers and shiny paper decorations. The group consisted of elders with mixed cognitive abilities. I teamed up with Mary, who had soft white hair, pink cheeks and big grey-blue eyes which shone with an inner light. She sat comfortably in her wheelchair and had a slightly distant air, as if she was not quite of this world. She declined my invitation to participate in the card making activity, saying that her hands shook too much nowadays. But she did agree to help me make a card and said that she would like it to be for her sister, Annie.

We worked together, with me taking guidance from Mary on decisions about colour, content, and message in the card. As we progressed, I gently questioned her about Annie. I came to understand that Mary could not remember when she had last seen her sister and that in fact she didn't even know if she was still alive. She became tearful as we let ourselves be drawn into the painful emotions of loss and regret that filled the air between us, but we simultaneously stayed focused on the activity at hand.

Making the card seemed to provide a steadying point, helping Mary to find her way through the confusion in her mind without becoming overwhelmed by the strong emotion, and enabling her to face the sad reality that she would never see her sister again. When it came to choosing the words for the message in the card,

Mary was very particular about finding the right ones. She did not accept any of my suggestions, or borrow words from the cards of other residents. She took the time to find exactly what she wanted to say. As I was writing the message she was finally happy with, Mary had an air of finality and certainty, as if something important and necessary had been achieved. The completed card in her hand, she seemed relaxed and calm, and thanked me for my help.

Upon reflection, I concluded that the act of making a card for Annie had provided the necessary containment for Mary to understand and accept the loss of her sister. Participating in a creative activity, albeit vicariously with a partner, enabled her to bypass cognitive impairment, access the unresolved emotion associated with absence of her sister, and to grieve and integrate this new reality. The act of engaging in the expressive arts became a symbolic ritual, a window of clarity which culminated in the touching closure message on the card:

Dear Annie.
I'm thinking of you today.
With love and affection from Mary

Challenging Mr Fox - by Lisl Foss

The tale of the Gingerbread Man had never been so much fun. I was sitting in the audience among a group of excited 4-6 year old children and in front of us a handful of elderly residents were enthusiastically enacting the timeless story of the gullible gingerbread man who came to his untimely end at the hands of crafty Mr Fox. The activity formed part of one of the ongoing creative arts programs at a care home, supporting their policy of encouraging residents to remain meaningfully engaged with children as well as adults. People are generally aware of the role that older persons can play in taking care of younger children but often those living with dementia lose status as helpful and contributing members of society.

Here a group of residents was busy challenging this myth! Audience and performers were in the compassionate and capable hands of the coordinator of the program who provided a steady presence and occasional direction. The concentration and focus in the room was palpable, with every resident putting heart and soul into the part he/she was playing. Both audience and actors were fully engrossed as the familiar tale unfolded. When someone had a forgetful moment and lost their place in the script, or turned to the wrong page, eager children or fellow actors jumped in to show the way. It was clear that no-one was bothered by these lapses in attention, and the story tumbled to its conclusion in joyous chaos.

But before we were done, a novel ending to this tale of woe ensued whereby the children were encouraged to protest Mr Fox's wrong and unkind treatment of the gingerbread man. They were invited to individually come up to Mr Fox and shout out "NO!!" to his face. The resident playing the part did a great job, jumping in fright and surprise, no matter how long it took for every child to have a turn at scolding him. His expressive body language made their exclamations even more powerful! The opportunity to voice resistance to the connivery of Mr Fox was teaching the children an important life lesson — that it is okay to speak up when someone takes advantage of another who is vulnerable. Through playing an active role in the story, the children were practicing how it felt to retain agency when one had been disempowered, like the poor gingerbread man who did not suspect that he would be eaten by Mr Fox. Going forward, it would be easier for them

(and possibly for some of the elders present) to "say no" in situations where their own, or the wellbeing of others was being compromised. I was left with a full heart at the privilege of witnessing how the production of a simple children's tale brought meaning and engagement into the lives of elders, whilst at the same time preparing the younger generation for dealing with life's challenges.

Intergenerational Programming (Jytte's comments)

There's a growing awareness of the importance of intergenerational programs like the one described in **Challenging Mr Fox.**

We were so lucky that Dad enjoyed the last five years of his life at Rosemont Assisted Living. He danced, sang, shared a late cup of coffee with the housekeeping staff — but the highlight of his week was Friday when kids from a local Montessori school came to visit.

The children who participated in this program were 3rd to 5th graders, still young enough not to necessarily be burdened by adult notions of how things are supposed to be done. Their enthusiasm and sense of wonder was infectious to the elders and in return the elders gave them full attention and appreciation. This program was ongoing for years, resulting in lasting relationships. My father loved these children, they'd share games, goofy stories, and art making. Dad and a nine-year-old collaborated on this collage, which he displayed prominently alongside his most treasured item.

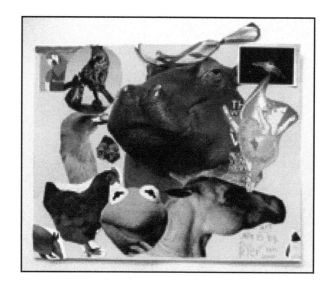

Stories

We have variations of story-telling and writing. First and foremost, personal stories and recollections of our residents. Seated in a circle, we'll typically start with a simple topic for discussion. A couple of examples: "When you were growing up, did you have a long walk to school?" Or "Did your mom have a special cookie she'd bake at holiday time?" - One time, as we went around the group as everyone shared their particular favorite cookies, without a spec of irony, one woman said, "My mother didn't know where the kitchen was." Everyone laughed. (I learned later that her family employed a sizable staff.)

Here are a few more topics that may help to inspire the group:
- When you were little, did you have a refrigerator or an icebox?
- Did the "iceman" deliver blocks of ice for your icebox?
- When you were little, what did you want to be when you grew up?
- Who was your first movie hero?
- When you were young, did you have a telephone with a party-line?
- Tell us about your first kiss.

The easiest way of getting everyone engaged in storytelling was to write a nonsense tale, is to have each participant come up with one paragraph at a time. If each paragraph ends in a "cliffhanger" you can go to the next person and ask, "So, what happens next," - You can assemble all the segments into a small "book" which can be printed and handed out to everyone.

If this project sounds a bit too involved for your group, another good option is to have families submit to you anecdotes or short stories about their loved ones. The best stories are those where he or she is at the center of the story. If you're recounting a humorous occasion, please be careful to maintain the dignity of your main character, your loved one.

Finish the story-writing session by reading out loud one or several of the stories. The next few pages give you other read-aloud stories.

Dumb Criminals

The following stories are all true and make excellent read-out-loud stories. Not only are they amazing or funny, but they also can lead to really good discussions.

A guy entered a bank and handed the teller a note that said: "I have a gun, give me your money." When the teller noticed that the demand was written on a deposit slip, she pointed to the logo on the slip and said, "I'm sorry Sir, I can't cash this. This is for a Wells Fargo account and we're Bank of America. You'll have to go to Wells Fargo Bank. You're lucky there's a branch right down the street" – The robber picked up the slip, left the bank and walked down the block where he was met by the cops. Oops!

A gang had decided to rob a bank. They rented the vacant storefront next door. They whitewashed the windows, pretending to be preparing to open a business. Once they felt confident that they'd figured out the location of the vault in the bank on the other side of the shared wall, they started digging through that wall. Working nights and weekends it took them more than a month but finally they broke through the brick wall — only to discover that they had made a slight miscalculation. They had dug a hole into the public restroom!

Another gang had decided to rob a jewelry store. They rented the storefront next door. They spent hours digging through the wall. When they finally had a hole they thought was big enough, the leader of the gang insisted on going first, so he stuck his head into the hole and started pulling himself through. He got his shoulders through okay but when he got to his belly, he ran into a problem. He was kind of pudgy and he started getting stuck, but he was stubborn, didn't want to give up, so he kept squeezing through, only to be totally jammed. When it was clear that he was hopelessly stuck, his comrades tried to pull him back out, but had to give up and call fire department to come to the rescue.

Smart Animals

Our groups particularly favor true tales of heroic and amazing animals. I've amassed quite a collection by now. Here are the synopses of a few favorites (Of course I elaborate in the retelling.)

Pig Hero: A woman had collapsed on the floor in her living room. Her pot-bellied pig managed to get out of the house to the road. He ran back and forth across the road until a driver stopped. The pig was so insistent that the driver followed him inside to find the woman unconscious on the floor. She had suffered heart attack and got help just in time, because of her smart piggy. (CNN report)

Dog Hero: A young woman had lost control of her car on a country road and plunged into a ravine, out of site of traffic. She didn't have the strength to get out by herself of her mangled car. She'd been stranded for almost two days, when a large German shepherd appeared out of nowhere, managed to pull her limp body out of the car and drag her up to the shoulder of the road. The dog stayed by her side until a driver finally stopped. As soon as it was apparent to him that she was going to be safe, the dog took off. The TV station that reported this was inundated with offers to adopt that dog. However he was never identified. (CNN report)

The Whale: A 50 Ft female humpback whale had gotten hopelessly entangled in crab netting off the coast of San Francisco. A group of rescue divers came to her aid. They dove into the water with her. She lay absolutely still while they carefully cut away the netting. A single swipe of her tail would probably have been fatal. The diver who had been working at her head, said that she never took her eye off of him and somehow he knew that she was totally aware that they were helping her. After she realized she was free, she swam in circles from one diver to the next, nuzzling each as if to thank them. (San Francisco Chronicle)

Smart Cat: When their water bill all of a sudden skyrocketed, a couple suspected a major leak in their waterline. They spent a fortune having all the lines checked, to no avail. All the joints and pipes were intact. – And the water bills remained high. Some time later the husband was home in bed with a cold when he heard the sound of a toilet flushing. He tiptoed into the bathroom to find his cat leaning over

the rim of the toilet, watching in fascination as the water swirled down. As soon as the tank refilled, kitty would pull the lever again. Nobody knows why the kitty performed his tricks only when his people were away.

Wolf Hero: In upstate NY couple in their eighties can thank Shana, their 160 lbs wolf-shepherd hybrid for their lives. They got caught in a fierce snowstorm in the forest. A large tree tumbled and trapped them. After Shana located them, the dog tunneled with her paws and teeth all the way to the house, came back, grabbed the sleeve of the wife's jacket, and threw the 86-pound woman over her back and neck. The husband grabbed hung on to her feet. With no power the house was freezing. Shana draped herself over the couple and kept them warm through the night. - Shana received the Citizens for Humane Animal Treatment's Hero's Award for bravery — an award traditionally given to humans.

Cat Burglar: Norris, a two-year-old tabby is a prolific cat burglar. He sleeps during day, but at night he prowls through the neighborhood and brings home all sorts of things: rags, underwear, socks, pizza slices, and even a bath mat. This had been going on for quite a while and his loot kept growing. He was finally caught in the act by security cameras that showed him roaming the neighborhood and raiding clotheslines, picnic tables, storage sheds. His humans set a room aside for his collection and notified all their neighbors to retrieve their things.

Poetry

Gary Glazner is the founder of the Alzheimer's Poetry Project. His favorite approach to getting people involved in poetry is to use "call and respond." - You call out one line at a time and the group repeats the line, hopefully with gusto.

There was a little girl,
Who had a little curl,
Right in the middle of her forehead.
When she was good,
She was very good indeed,
But when she was bad she was horrid. *(Henry Wadsworth Longfellow)*

How do I love thee? Let me count the ways.
I love thee to the depth and breadth and height
My soul can reach, when feeling out of sight
For the ends of being and ideal grace.
I love thee to the level of every day's
Most quiet need, by sun and candlelight.
I love thee freely, as men strive for right;
I love thee purely, as they turn from praise.
I love thee with the passion put to use
In my old griefs, and with my childhood's faith.
I love thee with a love I seemed to lose
With my lost saints. I love thee with the breath,
Smiles, tears, of all my life; and, if God choose,
I shall but love thee better after death. *(Elizabeth Barrett Browning)*

I go to the sea to be free
and it captures me
Susan Balkman

"A World of Dew"
by *Kobayashi Issa*
A world of dew,
And within every dewdrop
A world of struggle.

CONFETTI

My mind's not at all a blank slate,
Though I cannot keep track of the date
Or the day of the week,
And facts play hide-and-seek,
For my mind to be blank would be great.

Instead it is wired like spaghetti;
It conflates the important and petty;
The connections of things
Are like tangles of strings
Or like celebratory confetti.

*By Stuart Hall, "wordsmith" reading his poem
at the Alzheimer's Café in Santa Fe.*

Stuart had the perfect career for a person who loved the English language. He was a university librarian. When he needed purpose while living with dementia, it felt natural to him to resort to writing poetry. And he was prolific; according to his wife, he averaged thirty poems a day.

Addendum

Songbook

I've compiled a very short collection to get you started. Notice that the font is in upper and lower case (all upper-case and small print are both too hard to read). Although it takes more paper, please enlarge your text to 20-22 pt (see samples on the next page) and devote a separate page to each song. Each page is also numbered very clearly. (If any of our residents question the large type, I tell them that it's for me, so I don't have to use reading glasses!)

Copy the following to your computer and enlarge to one song per page (our songbooks are in **20 - 22** pt type)

PAGE 1

When The Saints Go Marching In

Oh when the Saints, oh when the Saints
Oh when the Saints go marching in.
I want to be in that number
When the saints go marching in.

Oh when the sun refuse to shine
Oh when the sun refuse to shine.
I want to be in that number
When the sun refuse to shine.

Oh when the Saints, oh when the Saints
Oh when the Saints go marching in.
I want to be in that number
When the saints go marching in.

Give My Regards to Broadway

Give my regards to Broadway,
Remember me to Herald Square,
Tell all the gang at Forty-second Street
That I will soon be there.

Whisper of how I'm yearning
To mingle with the old time throng,
Give my regards to old Broadway
And say that I'll be there, e'er long.

Moonlight Bay

We were sailing along on moonlight bay.
We could hear the voices ringing, they seemed to say:
You have stolen my heart, don't go away.
As we sang love's old sweet song on moonlight bay.

We were sailing along on moonlight bay.
We could hear the voices ringing, they seemed to say:
You have stolen my heart, don't go away.
As we sang love's old sweet song on moonlight bay.

Shine on Harvest Moon

Shine on, shine on harvest moon,
Up in the sky.
I ain't had no loving since
January, February, June or July.

Snow time ain't no time to stay
Outdoors and spoon.
So shine on, shine on harvest moon
For me and my gal.

Let Me Call You Sweetheart

Let me call you sweetheart, I'm in love with you.
Let me hear you whisper that you love me too.
Keep the love light glowing in your eyes so true.
Let me call you sweetheart, I'm in love with you.

Ain't She Sweet?

Ain't she sweet?
See her walking down the street.
Now I ask you very confidentially,
Ain't she sweet?

Ain't she nice?
Look her over once or twice.
Now I ask you very confidentially,
Ain't she nice?

Just cast an eye in her direction.
Oh me, oh my, ain't that perfection?

I repeat, don't you think it's kind of neat?
Now I ask you very confidentially
Ain't she sweet?

The Yankee Doodle Boy

I'm a Yankee Doodle Dandy,
A Yankee Doodle do or die,
A real life nephew of my Uncle Sam
Born on the Fourth of July.

I've got a Yankee Doodle sweetheart,
She's my Yankee Doodle joy.
Yankee Doodle came to London
Just to ride the ponies;
I am the Yankee Doodle boy.

Good Morning to You

Good Morning to You,
Good Morning to You, Everybody
Good Morning to You

This is a slightly revised version of the original "Good Morning to You, Dear Children", which was composed by two sisters, both teachers of young children.

Daisy Bell

Daisy, Daisy, give me your answer, do,
I'm half crazy all for the love of you.
It won't be a stylish marriage,
I can't afford a carriage,
But you'd look sweet upon the seat
Of a bicycle built for two.

Herman, Herman, Here is my answer true.
I'm *not* crazy
All for the love of you.
There won't be no kind of marriage
You can't afford a carriage
And I'll be damned
If I'll get crammed
On a bicycle built for two!

Sittercises

Sittercises provide a good workout for someone for whom walking, dancing and standing exercises are no longer options. Or you can use them to augment your other movement program. I often combine sittercises with our mini sing-alongs as our daily start-ups.

A few important issues to keep in mind:

- Enjoy yourselves (some of these moves look really silly, so laughing should come naturally. More about laughter in the Humor/Laughter segment)
- Most of the folks we work with are elderly, many have osteoporosis and are prone to fractures, for this reason all movements must be slow, smooth and gentle.
- Be especially careful with exercises involving bending down and coming up again. They should only be done very slowly.
- If someone shows signs of pain, have them skip that particular exercise.

The Routines

Everyone sits in a circle including you.
You'll do 3 to 5 slow repetitions of each exercise.

Raise arms, breathe in. Lower arms, exhale.
Extend arms out front, palms up, then down.
Reach down side of legs to touch toes.
Bend chin to chest, then look up at ceiling.
Raise shoulders up to ears.
Lean forward, clench fist, then pull back to row. Sing "Row, Row Your Boat."
Extend one arm out front, then back to opposite shoulder.
Extend other arm out front, then back to opposite shoulder.
Raise arms, breathe in. Lower arms, exhale.
Stretch arms out front and scissor.
Stretch one leg up slowly, then the other.

Stretch one arm to ceiling, then the other.

Keep heels on floor. Pull toes up and hold for 3 seconds.

Keep toes on floor. Pull heels up and hold for 3 seconds.

Raise arms, breathe in. Lower arms, exhale.

Extend arms out front, make fists, then open.

Keep arms out front and wiggle fingers.

Extend both legs, point toes out, and then up.

Stretch arms out front, bend wrists down, then bend up.

Keep arms out front, circle wrists.

Shake out arms.

Raise one knee up to chest, then the other.

Raise arms, breathe in. Lower arms, exhale.

Put hands on shoulders, raise up, pull elbows back and then together in front of chest.

Keep hands on shoulders and turn first to one side, then the other.

Clasp hands, raise above head, then down in front between knees, as if chopping.

Roll shoulders.

Raise arms, breathe in. Lower arms, exhale.

Give yourselves a big hug.

* * *

Additions

Using weights (commercial weights or cans of sodas or water bottles)

1. Keep elbows close to the side, hold weights in hands, palm turned up. Stretch lower arm out front, keeping elbows close to your side, then bring weights up toward shoulder. (10 times)

2. Weights in hand, your arms resting at your side, left them straight out to the side. (10 times)

3. Weights in hand, lift your arms straight up above your head. (10 times)

4. Weights in hand, from "goal post" position, keeping your elbows at 90° angle, lift up over your head. (10 times)

Word Game

A bird in the hand is worth two in the bush.

A friend in need is a friend indeed.

Absence makes the heart grow . . . fonder.

An apple a day keeps the doctor away.

An onion a day keeps everyone away.

Bad news travels fast.

Barking dogs never bite.

Beauty is in the eyes of the beholder.

Beggars can't be choosers.

Better safe than. . . . sorry.

Practice makes perfect.

Rome wasn't built in a day.

Strike while the iron is hot.

Curiosity killed the cat.

Do as I say, not as I do.

Don't bite off more than you can chew.

Don't count your chickens before they're hatched.

Don't cry over spilled milk.

Don't judge a book by its cover.

Don't put all your eggs in one basket.

Don't put off for tomorrow what you can do today.

Don't put the cart before the horse.

Haste makes waste.

He who laughs last, laughs best.

If you can't beat them, join them.

Love makes the world go round.

Misery loves company.

Money does not grow on trees.

No news is good news.

Nothing ventured, nothing gained.

Stupid Laws

These laws are on the books today!

It's illegal for a driver to be blindfolded while operating a vehicle. **AL**

It's illegal to wear a fake beard that causes laughter in church. **AL**

You may not have an ice cream cone in your back pocket at any time. **AL**

You must keep your elephant on a leash. **CA**

You can be stopped by the police for biking over 65 miles per hour. **CN**

You are not allowed to walk across a street on your hands. **CN**

It's illegal to shower naked. **FL**

It is illegal to tie a giraffe to a lamppost. **GA**

It's illegal to eat in a restaurant if it's on fire. **IL**

One-armed piano players must perform for free. **IA**

The fire department must practice for fifteen minutes before attending a fire. **IA**

In Marshalltown horses are forbidden to eat fire hydrants. **IA**

All fire hydrants must be checked one hour before all fires. **PA**

It's illegal to hunt whales. **KA**

A woman cannot buy a hat without the husband's permission. **KY**

You may not step out of a plane in flight. **ME**

Mourners at a wake may not eat more than three sandwiches. **MA**

It's legal for the blind to hunt, and they don't need anyone with them. **MI**

It's illegal to cross the Minnesota-Wisconsin border with a duck on your head. **MN**

Jumping off a building is punishable by death. **NY**

It's against the law to sing off key. **NC**

In Barber, North Carolina fights between cats and dogs are prohibited. **NC**

Women are prohibited from wearing patent leather shoes in public. **OH**

It's against the law to kill a housefly within 160 feet of a church without a license. **OH**

Riding on the roof of a taxicab is not allowed. **OH**

Violators can be fined, arrested or jailed for making ugly faces at a dog. **OK**

Dogs must obtain a permit in order to congregate in groups of three or more **OK**

It's illegal to sleep on top of a refrigerator outdoors. **PA**

It's legal for a husband to beat his wife with nothing bigger than his thumb. **TX**

Quotes Plus

• We asked Jack Benny to give the bride away, but Jack said he never gave anything away. (Gracie)

• You've got to be honest; if you can fake that, you've got it made. (George Burns)

• I am a marvelous housekeeper. Every time I leave a man I keep his house. (Zsa-Zsa)

• Personally I know nothing about sex because I've always been married. (Zsa-Zsa)

• Before you try to keep up with the Joneses, be sure they're not trying to keep up with you. (Erma Bombeck)

• The pen is mightier than the sword, and considerably easier to write with. (Marty Feldman.)

• Old Age is not for sissies. (Talulah Bankhead)

• We asked Jack Benny to give the bride away, but Jack said he never gave anything away. (Gracie)

• You've got to be honest; if you can fake that, you've got it made. (George Burns)

• I am a marvelous housekeeper. Every time I leave a man I keep his house. (Zsa-Zsa)

• Personally I know nothing about sex because I've always been married. (Zsa-Zsa)

• I wonder if other dogs think poodles are members of a weird religious cult (Rita Rudner)

• Before you try to keep up with the Joneses, be sure they're not trying to keep up with you. (Erma Bombeck)

• The pen is mightier than the sword, and considerably easier to write with. (Marty Feldman.)

•Old Age is not for sissies. (Talulah Bankhead)

<div align="center">***</div>

I also collect true trivia:
True: Queen Elizabeth I was regarded as very fastidious because she took a bath once a month.

Also true: When Queen Elizabeth I decided to be known as the "Virgin Queen", she changed her look by using cornstarch as face powder. When she died, her cornstarch mask was almost one inch thick.

And one-liners:
We divorced over religious differences. He thought he was God and I didn't.

Grandma started walking five years ago; we have no idea where she is now.

–And something we probably all could agree upon:

Life is Uncertain – Eat Dessert First

The Alzheimer's Café

Hopefully you have an *Alzheimer's Café* or *Memory Café* near you

What? The Alzheimer's Café is a social event that gives everybody involved with Alzheimer's or other dementias a respite from issues relating to the disease. A very simple idea: a monthly gathering in a friendly space where caregivers, professionals, families, and people living with dementia can relax, have fun, and form friendships for mutual support.

Why an Alzheimer's Café? - In our culture we segregate our elders; we take them out of circulation in the name of "caring for them." We move them into care facilities, away from the rest of the population. This is especially true of people with Alzheimer's and other dementias, who may be housed in "secure" wings, — or as one of my "secure wing" resident friends calls it: "the lock-down."

The loneliness and isolation may be even worse for people who live at home with family or caregivers. More often than not their primary contacts with the outside world are trips to doctors' offices and other appointments of necessity. When a family member is living with dementia, the rest of the family is living with the disorder as well and it's a constant presence that affects everything that everyone does. Sadly, as dementia progresses, it's almost impossible to prevent this situation from leading to increasing isolation for both the persons living with dementia and their caregivers. An Alzheimer's Café provides this population with an opportunity to enjoy a public event that's safe, non-judgmental, and fun.

Who? The Alzheimer's Café gives people with the disease and with their caregivers the opportunity to share a rare positive experience. It's time to just be, to let their hair down without judgment, and escape their respective roles. They get to laugh, sing, dance, explore art, music, poetry and RELAX. Acceptance and love are the keystones of these cafés. Over the years, many of our families have formed long-term friendships and have become important supports for each other. This has been especially valuable to the individuals with dementia; they are after all the only ones who truly understand each other.

Why *Alzheimer's* Café? - Several other similar projects in the US have chosen to use the term **Memory** Café. When I first mentioned to my colleagues that I was starting the *Alzheimer's* Café, they questioned whether people would want to attend an *Alzheimer's* Café and they suggested changing the name to something innocuous, like "Maria's Place". But I felt it was important to confront the stigma of this disease head on.

Who? Very importantly: We have never "screened" our guests nor will we ever set any criteria for participation. Everyone is welcome, whether they have mild MCI or are in the advances stages of Alzheimer's; or whether they are caregivers, family members or members of the community, simply interested in Alzheimer's and dementia. As I tell those who ask: "You're not required to have any kind of dementia," - A note: A few times, people have taken me up on it and usually express surprise that they were unable to distinguish those with dementia from those without.

When? Our café meets the second Wednesday of the month from 2 to 4 in the afternoon. The timing was quite deliberate: 2 pm is after lunch and naps and 4 pm precede dinner and dusk. (Many of our caregivers are elderly and don't like to drive in the dark.) Our set schedule allows people to drop in with no advance notice. It's an open invitation to the community at large. One of the support groups meets on the second Tuesday of the month, usually the evening before the café. This gives us a chance to follow-up in a relaxed atmosphere.

Where? When I started the first café in 2008, I felt it was important to be in a "neutral" space, not associated with any eldercare institutions, medical facility, or a particular religious denomination. These parameters made it tough to find a location at little or no cost. For the first year we were at the College of Santa Fe (the space was too big) and later in the community room of an apartment complex (it was okay, but a bit sterile). Luckily we connected with the Santa Fe Children's

Museum, where we have use of their colorful classrooms. At first, we were concerned that it's a bit too small for activities such as dancing. However, being housed in a place designed for young children has been well worth the trade-off.

One of the first cafés to start after ours is also in a children's museum. In this case in New Hampshire. Other cafés around the country are held in a variety of venues, including a theater, ice cream parlors, and pizza parlors. Hopefully, you have a café near you. Even if it meets only once a month, a café often has a powerful impact on everyone involved.

The Alzheimer's Café is the brainchild of Dutch psychiatrist Bere Miesen, who pushed the concept of social interaction as key to slowing down Alzheimer's devastating effects on the brain. In 1997 he opened the first Alzheimer's Café near Amsterdam. Miesen explains: "The Alzheimer's Café is an informal way to make contact with each other, to receive a consultation and feel at home. In the Netherlands, patients feel they have a place to just be. This way the patients and their families don't have to deny or avoid the illness." (Dr Miesen's café follows the *European model,* where socialization is combined with formal information/discussions.)

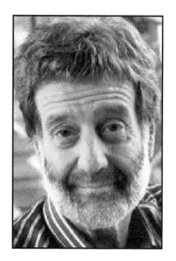

We were the first in the United States! At the time I started our café in Santa Fe, NM, I assumed that I was a Johnny-come-lately and just hadn't had enough time to find others in this country. It was a surprise to learn that we were in fact the very first and only Alzheimer's Café in the northern hemisphere. This remained so until a national magazine mentioned us in an article in 2011. My phone started ringing off the hook. I was delighted to help numerous other communities get their projects up and running. The hundreds of cafés now operating in the US and Canada fall into two broad philosophies: the **American Model** as practiced by our group in Santa Fe and the **European Model** as seen in the NL, UK, and other European countries. A few of the American programs have taken their cafés a step further, expanding into their communities, local parks, and special gardens designed to accommodate people at all levels of cognitive and physical abilities.

European model of the Alzheimer's or Memory Café

Most of the Dutch Alzheimer Cafés and the British Memory cafés have a focus different from the American model. They often have invited speakers who give presentations on issues relating to Alzheimer's and dementia disease followed by a social hour. Some US cafés follow this model of combining social interaction with presentations, discussions, and professional advice on dementia and caregiving issues. Some offer onsite counseling as well.

American model of the Alzheimer's (or Memory Café)

The American model of the Alzheimer's or Memory Café celebrates the individual beyond the disease. It's a respite from issues relating to the diseases. Our community already offers several support groups as well as workshops on Alzheimer's, dementia, and caregiving, so our Alzheimer's café focuses on the social and emotional needs of our guests. We explore art, music, poetry and simple fun. Laughter, love and merriment are the keystones of these cafés. Since we opened our doors in October 2008 in Santa Fe, NM, we've had a steady crowd, who collectively decide our "programming." I think of the café as a monthly celebration or party. We have sing-alongs, make art, have discussions of all sorts and always try to laugh a lot, all of it loosely planned.

At one of our gatherings I noticed a woman standing just inside the door, surveying the crowd of merrymakers. After a while I walked up to her and invited her to join us, but she dismissed me, saying that she would join us as soon as "the Alzheimer's people" showed up. I had to chuckle to myself. She obviously couldn't tell who was who among all the folks who were laughing, chatting, singing, and obviously enjoying themselves. – We were on the right track!

The Mantra of the Alzheimer's Café is

Love And Acceptance

Starting Your Own Café

Venue:
1. A venue with a warm and inviting atmosphere, not too big and not too small. (If possible at no charge.)
2. Comfortable furniture. (We like a single oversized table with enough chairs for all our guests – up to 20.)
3. Easy access
4. Plentiful parking
5. Wheelchair accessibility and handicap parking
6. Preferably a venue not related to anything having to do with elders or the medical community. (Several groups meet in commercial cafés. Others meet in theaters and two in Children's museums.)
7. If your facility offers continuing care, how about holding the café in the independent living wing? –and inviting the independent residents to join in the fun.

Details:
1. Leaders with experience with Alzheimer's and dementia
2. Decide which model you want to follow: The European or the American
3. Leaders committed to an ongoing project (consistency and continuity are important)
4. A modest spread of snacks, fruit, and drinks
5. Fun activities: music, arts and crafts projects (see addendum)
6. Guests (Speakers if you're following the European Model)
7. A set time and place
8. Open invitation to the community at large
9. Establish relationships with local media
10. Add your café to the national registry.

AND: Use ideas from this book for activities and fun stuff to do.

What we've learned:
1. Let go of expectations. You never know who'll show up.
2. No solicitations!
3. Our philosophy for the *American Model*: We think of our café as we would a private party at our own house. It's first and foremost a celebration. That does not preclude spontaneous conversations of any sort, including "serious" topics.

A notes from a few of our guests in Santa Fe:

• Thank you so much for all your work in putting on the Alzheimer's Café. I believe that it was God's plan with the way we heard about it. During the course of my husband's disease things have just come to us when we needed it most. That day (the café] has meant so much to my husband and me. I saw a part of him that I had not seen in a very long time. He was smiling, confident, uninhibited. These things have all been partially missing for the past seven years. Thank you for your work and commitment to others with dementia.

• And for the caregivers, too. The husbands and wives, sons and daughters. The Alzheimer's Café is a brief chance to enjoy the company of those in the same situation. To check in with each other. A time and space to forget about forgetting, at least for a little while.

• Thank you Jytte, We'll be there in March. Your guidance and support are such a Blessing to us. Thank you. Thank you, Thank you.

• It's more relaxed, it's easy going, and it's fun. We're seeing incredible support from strangers. You've go several people who have no connection to you and they're saying, 'Hey come here, let's talk'.

• At the Alzheimer's café we gather to share, sing, laugh, create and be together without the stigma for the caregiver and for the person with memory loss. If you were to visit the Alzheimer's Café, my guess is you would not know whose memory has been lost. You would just see a group of folks having fun, relaxing and enjoying being together.

• The Alzheimer's Café's business is – laughter, camaraderie, understanding, relaxation, information, art and music in the midst of the often bleak clinical world of "living with dementia." The café is open to those diagnosed with memory loss and those family members, friends, and professionals who care for persons with memory loss. I'm acutely aware of the daily grind of isolation, doctors' appointments, little social contact, medicines, fear, shame, burnout, frustration and extreme fatigue for both caregivers and the ones cared for.

Collaborations

Since the start of the Alzheimer's Café in 2008, hundreds more communities all over the country have been started their own cafés. Over the years, many cafés have collaborated and shared ideas to improve and grow the concept.

The cafés serve the important function of giving both care partners the opportunity to share a relaxed and fun experience while they enjoy a respite from their regular roles. The cafes are focused on the abilities rather than the disabilities brought on by the dementia.

Most of us hardly ever hear directly from people living with dementia. Sadly, this is true of most national conferences focused on elder issues. This changed when the Dementia Action Alliance (DAA) was formed specifically to give people with dementia a platform. At their first conference in 2017 all panels and workshops featured people with dementia as presenters. For most of the attendees, this was the first time they'd heard from that many people living very different lives with dementia. For years I had presented at national conferences for years with valuable and interesting information. This conference was different. Rather than discussing what we can do for *them,* i.e. our clients or patients, here we were discussing *us* as in what can we do together. - This was an amazing experience that touched all of us.

One of the main take-aways from the initial DAA conference was the importance of everyone having purpose in their lives and the most frequently mentioned tools were the arts. Subsequently, the 2019 conference was to be focused on the arts, with an exhibition of art works created by people with dementia from all over the country. We put out a call for entries to programs in facilities as well as many in community venues, senior centers, and libraries.

We received numerous submissions, including only two that were obviously from individuals who had studied art — all the rest were from people who were making art for the first time as adults. The works were almost all cheerful and positive.

Some works from the Dementia Arts show in Atlanta, GA in June 2019.
Many of the entries depicted animals.

The watercolors below were done by two individuals who had no prior experience making art and only became artists because of dementia.

Right: Daniel Potts tells how his dad found his purpose in his new passion: Painting watercolors.

Above and right: Mike Belleville's watercolors express his zest for life even as he's had to adjust to life with Alzheimer's. He's also become an prolific cook, who's been sharing his mouth-watering concoctions on social network sites.

Making Stuff Up

I'm borrowing a point made by my friend, best-selling author Marilyn Ferguson. At one of her seminars, she handed out tee shirts emblazoned with the insignia of **MSU**. Marilyn explained that it stood for *Making Stuff Up* to remind us that aside from our mammalian basic needs of food, shelter, sex, and sleep, EVERYTHING was *made up* by somebody at some point and thus can be unmade or changed.

Thankfully there are many innovators who take this to heart. Many members of groups like the Pioneer Network, Eden Alternative, the GreenHouse projects, and Dementia Action Alliance continue to innovate new approaches and ideas on everything related to caring for and living with dementia, as well as the issues to come with aging. Some are redesigning facilities to be more "user-friendly". Existing large nursing homes are being remodeled within into smaller units to help residents form "neighborhoods." And some new facilities are going in a completely different direction. The recent novel coronavirus pandemic revealed the gaping flaws in our current approaches to nursing home design, where the close quarters exposed far too many elders to the deadly virus.

The Green House Project starts with a compound of 6 to 8 units, each house to around ten residents, sharing the grounds, vegetable gardens, animals (i.e., chickens, rabbits and goats), — and in urban situations, the common areas.

But more important than the physical structures are the changes in organization that switch from top-down decision-making to collaboration of everyone affected by decisions, starting with the wishes, needs and wants of the residents, — after all it's about their lives and wellbeing. One person may find her purpose in repeatedly organizing her collection of rocks, while another needs to feel that his activities support his community, so he assigned himself to clear tables after meals; staff left him alone to finish to his own satisfaction. This approach is a component of what's known as "person-centered care."

A couple of examples of creative approaches and *making stuff up*:

The Helping Hands Handmade Soap Project. The *Mission View Health Center,* a large continuing care facility in San Luis Obispo repeatedly earned top ratings from the state of California, but even so, the director realized that something was missing. He called a meeting with the residents. They explained how everything was done for them, leaving them feeling useless. He asked them to brain-storm on solutions and told them, whatever they came up with, he'd make it happen, if at all possible. After much discussion, they came up with the *Helping Hands Handmade Soap Project.* It was the perfect project to get everyone involved. The residents used plastic molds to cast colorful glycerin soap bars and wrapped them in tissue paper decorated with water color and then finished them off with labels and bows. It was the kind of project that easily could involve everyone from both assisted living and memory care. The residents set up a booth at the local farmers' market and soon had sold so much soap and made so much money that they established a 505(c)3 non-profit, owned and controlled by the residents. The soap project was soon expanded to include a food program for the homeless. I suggest you take a look at the YouTube videos.

Helping Hands Handmade Soap Project.
https://missionviewhealthcenter.com/
http://youtu.be/G9r5sVbZOx4

Through the Looking Glass. An empathy crash course at a large nursing home in Illinois. Staff volunteers participate in a contest of who can live the longest as "residents" with various typical physical or cognitive obstacles faced by elders, such as stroke or Alzheimer's. The contestants went to activities and meals according to the schedules and they all had to experience "incontinence" and being bathed and dressed by "strangers" - The experiment results surpassed the most optimistic expectations of the organizers. There was a marked shift in relationships between staff and residents, not just for the contestant but for all the staff.

Video: *Through the Looking Glass* Aviston Countryside Manor.avi
https://youtu.be/Lr1KW2Kh4wM

Worth your attention

After a couple of years of my involvement with this population, I wanted more information, ideas, and just simple awareness. I started to seek out organizations, public events, and conferences. My first national conferences were the Alzheimer's Association and the ASA/NCOA (American Society on Aging/National Council on Aging.) I expanded my scope, was invited to speak at these and other national conferences. The following are the organizations whose programs and conferences I've found most helpful. - The descriptions are from their websites:

Dementia Action Alliance:

• The Dementia Action Alliance USA is a non-profit national advocacy and education organization of people living with dementia, care partners, friends and dementia specialists committed to creating a better country in which to live with dementia. We educate about stigma and misperceptions; support well-being and a focus on the whole person rather than just their dementia symptoms; advocate for inclusion and accommodating dementia as a disability needing compensatory strategies for changing abilities; promote person- and relational-centered care practices; identify beneficial technologies; and connect and engage people as much more can be accomplished working together.

> *https://www.DAANow.org*

The Pioneer Network:

• Changing the Culture of Aging in the 21st Century. - Pioneer Network is the national leader of the culture change movement, helping care providers to transition away from a medical, institutional model of elder care to one that is life affirming, satisfying, humane and meaningful. Pioneer Network advocates for a culture of aging in which individual voices are heard and individual choices are respected. Our goal is transformational culture change in organizations to foster care that is directed by the person receiving it.

> *https://www.pioneernetwork.net/*.

Eden Alternative:

• In a culture that typically views aging as a period of decline, the Eden Alternative philosophy asserts that no matter how old we are or what challenges we live with, life is about continuing to grow. Building on this new paradigm, it affirms that care is not a one-way street, but rather a collaborative partnership. All caregivers and care receivers are described as "care partners," each an active participant in the balance of giving and receiving. Together, care partner teams strive to enhance well-being by eliminating the three plagues of loneliness, helplessness, and boredom.

• Focused on changing the culture of care since the early 1990s, this approach to person-directed care initially came to life in nursing homes and has since expanded its reach to all care settings, including home care and residential care for people living with different abilities. The Eden Alternative firmly believes that culture change unfolds one relationship at a time, and that deep change can only take root when the entire continuum of care is involved. Through education, consultation, and outreach, it currently offers three applications of its principles and practices to support the unique needs of various living environments, ranging from the nursing home to the neighborhood street.

https://edenalt.org

Music and Memory

MUSIC & MEMORY® is a non-profit organization that helps individuals with a wide range of cognitive and physical conditions to engage with the world, ease pain, and reclaim their humanity through the use of personalized music playlists. We train nursing home staff and other elder care professionals, as well as family caregivers, to create, provide, and manage personalized playlists using digital music players that enable those struggling with Alzheimer's, dementia, and other cognitive and physical challenges to reconnect with the world through music-inspired memories. By providing access and education, and by creating a network of MUSIC & MEMORY® Certified organizations, we aim to make this form of personalized therapeutic music a standard of care throughout the health care industry.

https://musicandmemory.org/

Good to know

Montessori Method for Dementia:

How Caregivers Can Use the Montessori Method for Dementia

Dr. Cameron Camp, a psychologist in applied gerontology, discovered that the Montessori Method could be adapted into the basis of a new approach to dementia care. Dr. Camp states the problem this way: "How can we connect with the person who is still here?" One answer to this question is to use the Montessori approach to re-engage the types of memory that are spared by dementia, including motor memory such as how to dress and how to eat.

https://www.alzheimers.net/montessori-method-dementia/

Alzheimer's Foundation of America (AFA)

• AFA was founded in 2002 by a caregiver whose mother lived with Alzheimer's disease from 1980-1992. At that time, there was little information available and nowhere to turn for support. His goal was to make sure that no other family living with Alzheimer's disease would have to go through the journey alone.

• AFA operates a National Toll-Free Helpline (866-232-8484), staffed entirely by licensed social workers, which provides support and assistance to callers, as well as connect them with resources in their area, no matter where in the United States they live. The helpline has grown into a seven-day a week service. AFA's national network of more than 2,700 member organizations serves families affected by Alzheimer's disease and other dementia-related illnesses in each of the fifty states.

• To help individuals take a proactive approach to brain health, AFA has a National Memory Screening Program which provides, free, confidential memory screenings at sites across the country. What began as a program on a single day in November has grown into a year-round service which has screened more than 5 million people to date.

https://alzfdn.org/

Ombudsman Program

Long-term care ombudsmen are advocates for residents of nursing homes, board and care homes and assisted living facilities. Ombudsmen provide information about how to find a facility and what to do to get quality care. They are trained to resolve problems. If you want, the ombudsman can assist you with complaints. However, unless you give the ombudsman permission to share your concerns, these matters are kept confidential. Under the federal Older Americans Act, every state is required to have an Ombudsman Program that addresses complaints and advocates for improvements in the long-term care system.

Residents' Rights

• **The right of citizenship**. Nursing home residents do not lose any of their rights of citizenship, including the right to vote, to religious freedom and to associate with whom they choose.

• **The right to dignity**. Residents of nursing homes are honored guests and have the right to be so treated.

• **The right to privacy**. Nursing home residents have the right to privacy whenever possible, including the right to privacy with their spouse, the right to have their medical and personal records treated in confidence, and the right to private, uncensored communication.

• **The right to personal property**. Nursing home residents have the right to possess and use personal property and to manage their financial affairs.

• **The right to information**. Nursing home residents have the right to information, including the regulations of the home and the costs for services rendered. They also have the right to participate in decisions about any treatment, including the right to refuse treatment.

• **The right of freedom**. Nursing home residents have the right to be free from mental or physical abuse and from physical or chemical restraint unless ordered by their physician.

• **The right to care**. Residents have the right to equal care, treatment and services provided by the facility without discrimination.

• **The right of residence**. Nursing home residents have the right to live at the home unless they violate publicized regulations. They may not be discharged without timely and proper notification to both the resident and the family or guardian.

• **The right of expression**. Nursing home residents have the right to exercise their rights, including the right to file complaints and grievances without fear or reprisal.

Supplies and Tools

Michael's Art Supplies has a wide national network of brick and mortar stores as well as *order online/pick up in store*.

https://www.Michaels.com

Dick Blick Art Supplies is my "go-to" online source for canvas, artists' brushes, acrylics and Porcelaine paints. They also have a wide variety of fabric paints and dyes; clay and potters tools.

https://www.DickBlick.com

Discount School Supplies is a good source for certain tools and supplies that we use in our programs, i.e., scissors, glue-sticks, tape, as well as a great selection of craft supplies.

https://www.DiscountSchoolSupply.com

Nasco is another good source of supplies and kits for art and science projects.

https://www.enasco.com/c/Art-Supplies-Crafts

Videos and Books

Alive Inside - The full length documentary on music and memory is available on YouTube: https://www.youtube.com/watch?v=erhVJGrENEo - YouTube also has a short excerpt: "Henry hears music."

Alzheimer's Poetry Project: Gary Glazner started this great endeavor in 2004. *Glazner, Gary:* Dementia Arts, Celebrating Creativity in Elder Care; 2014;Health Professions Pr; ISBN-978-1938870118

Dance Therapy: https://www.danceforconnection.com/

Frye Museum, Seattle: Creative Aging programs: Here:Now and Bridges; https://fryemuseum.org/creative_aging/

Museum of Modern Art, NYC: Meet Me at MOMa; https://www.moma.org/visit/accessibility/meetme/

Music and Memory - https://musicandmemory.org/

Raichle, Marilyn: The Art of Alzheimer's Blog: https://theartofalzheimers.org/

Shouse, Deborah: Connecting in the Land of Dementia: Creative Activities to Explore Together; 2016 Central Recovery Press; ISBN-9781942094241

Lokvig, Jytte Fogh: The Alzheimer's and Memory Café, How to Start and Succeed with Your Own Café. http://www.AlzheimersCafé.com

Barsness, Sonya: https://beingheard.blog/author/sabarsness/ great writings

Swaffer, Kate: What the hell happened to my brain?: Living Beyond Dementia; Jessica Kingsley Publishers; 2016; ISBN978-1849056083

Taylor, Richard: Alzheimer's from the Inside Out*;* 2010, Baltimore, MD, Health Professions Pr; ISBN978-1932529234

Coste, Joanne Koenig; Learning to Speak Alzheimer's: A Groundbreaking Approach for Everyone Dealing with the Disease, 2004. Boston; ISBN0618485171

Dennis, Ruth; Luke Nachtraub; Velma Arellano: Mindful Dementia Care: Lost and Found in the Alzheimer's Forest, Santa Fe, NM, Golden Word Books, 2019; ISBN9781948749145

CMS Hand in Hand: A Training Series for Nursing Homes
https://qsep.cms.gov/pubs/HandinHand.aspx

Power, G. Allen; Dementia Beyond Disease: Enhancing Wellbeing, 2014, Baltimore, MD, Health Professions Pr; 978-1938870132

Huebner, Berna G; I Remember Better When I Paint: Art and Alzheimer's: ISBN-0976136449

Conoway, Patricia; Listening With My Eyes: 2015, Santa Fe, Conoway. ISBN.978-1943090358

Art saves lives, Ruth Dennis
https://youtu.be/qDtCk9bzqn0

Training Programs

The Center for Applied Research in Dementia develops, innovates, and applies its Montessori Dementia methodology with a specialized team of diverse scientific professionals.

> https://www.cen4ard.com/who/

Your author, Dr. Jytte Lokvig offers customized onsite Montessori staff training
> Lokvig@gmail.com

In the Moment. Karen Stobbe is a pioneer in creative caregiver training:
> www.inthemoment.net -

Care Academy is a training program based on methods developed by Teepa Snow
> https://careacademy.com

> Also, *the Alzheimer's Association and Alzheimer's Foundation.*

About Your Author

Jytte Fogh Ph.D. is a nationally recognized Alzheimer's and dementia specialist who has been an active proponent of progressive and person-centered eldercare since the late 1990s. The author of several popular books and guides on using the arts and person-centered approaches for effective eldercare, she's frequently invited to speak at conferences and other national events.

Growing up in Denmark, Jytte was surrounded by creators and innovators who encouraged and supported her community activism. She started at an early age developing programs for her schoolmates, a weekly movie club, an open art studio, and a nature explorers' group. Later, she organized local families to open their homes on weekends and holidays to international students who were stranded at their boarding school.

After coming to the United States as a young adult, she settled in Southern California, attended Art Center of Design and later earned her degrees from Antioch/West, UCLA, CSULA, and CSU. Following in her artist father's footsteps, she was an exhibiting artist and later expanded into fashion design, community celebrations, arts advocacy, and art education. After the Watts uprising in the mid-sixties, she and her husband worked with neighborhood youths to create the Watts Happening Coffeehouse, which has continued to be a hub for creative programs in the neighborhood. She was a founding staff member of the first publicly funded experimental school in Los Angeles.

Dr. Lokvig is a proponent of the Montessori philosophy, as an educator as well as a dementia and Alzheimer's specialist. The Montessori philosophy is based on supporting individuals in pursuing their own interests to the best of their ability. She holds several national and international certifications.

CPSIA information can be obtained
at www.ICGtesting.com
Printed in the USA
LVHW070404190321
681908LV00021B/419